The Museum of Anthropology
at the University of British Columbia

EDITORS

Carol E. Mayer, Curator (Oceania and Africa, Department Head)

Anthony Shelton, Director

CONTRIBUTORS

Pam Brown, Curator (Pacific Northwest)

Karen Duffek, Curator (Contemporary Visual Arts and Pacific Northwest)

Elizabeth Lominska Johnson, Curator Emerita (Asia, Research Fellow)

Jasleen Kandhari, Art Historian (Asia)

Jennifer Kramer, Curator (Pacific Northwest)

Krisztina Laszlo, Archivist

Bill McLennan, Curator (Pacific Northwest)

Susan Rowley, Curator (Public Archaeology and Circumpolar)

Ann Stevenson, Information Manager

The Museum of Anthropology
at the University of British Columbia

Douglas & McIntyre
D&M Publishers Inc.
Vancouver/Toronto

University of Washington Press
Seattle

Douglas & McIntyre
An imprint of D&M Publishers Inc.
2323 Quebec Street, Suite 201
Vancouver BC Canada V5T 4S7
www.douglas-mcintyre.com

Published in the United States by
University of Washington Press
PO Box 50096
Seattle WA 98145-5096 USA
www.washington.edu/uwpress

Library and Archives Canada
Cataloguing in Publication
The Museum of Anthropology at the
University of British Columbia /
Carol E. Mayer and Anthony Shelton, editors.

ISBN 978-1-55365-415-5

1. University of British Columbia. Museum
of Anthropology. I. Mayer, Carol E. (Carol
Elizabeth), 1945– II. Shelton, Anthony
GN36.C32V35 2009 301.074′71133
C2009-904591-5

Library of Congress
Cataloging-in-Publication Data
The museum of anthropology at the university
of British Columbia / edited by Carol E. Mayer
and Anthony Shelton.
p. cm.

ISBN 978-0-295-98966-2 (pbk. : alk. paper)

1. University of British Columbia. Museum
of Anthropology—History. 2. Ethnological
museums and collections—British Columbia—
Vancouver—History. I. Mayer, Carol E.
(Carol Elizabeth).– II. Shelton, Anthony.
GN36.C22v366 2009 301.074′71133—dc22
2009033901

Editing by Barbara Pulling
Copy-editing by Ann-Marie Metten
Cover and interior design by Peter Cocking
Front cover photograph by Bill McLennan
Back cover photographs by Bill McLennan
(bee masks) and courtesy of the
Museum of Anthropology (all others)
Photograph on page 216 © 2009 by Ken Mayer
Printed and bound in China by
C&C Offset Printing Co., Ltd.
Printed on acid-free paper

Douglas & McIntyre gratefully acknowledges
the financial support of the Canada Council
for the Arts, the British Columbia Arts
Council, the Province of British Columbia
through the Book Publishing Tax Credit and
the Government of Canada through the Book
Publishing Industry Development Program
(BPIDP) for our publishing activities.

Dimensions of works of art are given in metric,
in the order of largest to smallest

Contents

Acknowledgements

We would like to express our gratitude to all the people who have helped in the writing of this book and who were so generous with their insights and intellectual guidance. They worked with the authors to ensure as far as they could that the information about the objects was both correct and appropriate. They include Karen Anderson, Sonny Assu, Kimberly Baker, John Bennett, Veronica Bikadin, Violet Birdstone, Dempsey Bob, Tanya Bob, Suchen Susan Chang, Dr. Choi (Hae-yool), David Stewart Clellamin, Tiago Coen, Farouk Elesseily, Changhyun (Kevin) Han, Ho Ping-ti, Lorraine Hunt, Stephen Inglis, Lois Joseph, Kazuko Kameda-Madar, Colleen Lanki, Nicky Levell, Melvina Mack, Carolyn MacLulich, Joe Martin, Richard Morgan, Blanca Muratorio, Susan Nelson, Edwin Newman, Jo-Ann Osei Twum, Zoe Pei-Yu Li, Nuno Porto, Marcie Powell, Ralph Regenvanu, Pilar Riano-Alcala, Kathy Road, Abe Ross, Audrey Shane, Leona Sparrow, Wedlidi Speck, John Stanton, Paula Swart, Clyde Tallio, Paul Tapsell, Eiji Toda, William Wasden, Jr., Caroline Williams and Jacqueline Windh. As well, we also express our recognition of Museum of Anthropology staff members who contributed to the development of this book. These include Krista Bergstrom, Nancy Bruegeman, Sarah Carr-Locke and Ann Stevenson. Finally we thank Scott McIntyre of D&M Publishers Inc., Barbara Pulling for her meticulous and thoughtful editing, and Peter Cocking for his creative vision in the design of this book.

The photography for this book was generously supported by the Audrey Hawthorn Fund for Publications in Museum Anthropology. Digital imaging was supervised by Jessica Bushey, who was ably assisted by Kyla Bailey, Timothy Bonham, Rebecca Pasch and Derek Tan. Photographs from other sources are as follows: the photos on pages viii, 4, 7, 16, 35, 36, 42, 43, 44, 46, 48, 51, 53, 56, 114, 118, 172 and 213 were taken by Bill McLennan, the photo on page 216 was taken by Ken Mayer, and the photo on page 3 was taken by Goh Iromoto.

Museum of Anthropology programs are supported by visitors, members and donors; Volunteer Associates and Shop Volunteers; Canada Foundation for Innovation; Department of Canadian Heritage Museums Assistance Program; Department of Canadian Heritage Cultural Spaces Program; Young Canada Works in Heritage Organizations; Canada Council for the Arts; Canada Council of Archives; Social Science and Humanities Research Council; BC Knowledge Development Fund; BC Arts Council; Aboriginal Career Community Employment Services Society; The Koerner Foundation; Vancouver Foundation; TD Bank Financial Group; Canadian Society for Asian Arts; D&M Publishers Inc., and UBC Faculty of Arts.

Director's Foreword

The Museum of Anthropology is a museum of world arts and cultures with a special emphasis on the First Nations peoples and other cultural communities of British Columbia, Canada. In the pages that follow, we are proud to present the many facets that make up the museum.

The museum building embodies the essence of Canada's West Coast. In the museum's Great Hall, massive and magnificent First Nations sculptures stand against a soaring glass wall that opens onto a panorama of forested islands and snow-capped mountains bordering the Salish Sea. Outside, eagles glide and ravens caw under a sky whose subtle, constantly changing colours and tones form a backdrop for the stories and performances choreographed in the museum's exhibition galleries. Designed by architect Arthur Erickson to sit on a steep promontory, the building takes its inspiration from the cedar post and beam constructions found in traditional Northwest Coast Aboriginal villages. Erickson himself has described the museum as "a work of light and shadows, a building perfectly harmonized and nestled in its landscape, designed to resonate to the metronome of the seasons and diverse cultural collections which it houses." The Welcome Plaza, at the top of the steps leading to the museum's entrance, incorporates an installation titled *Transformation* by Musqueam artist Joe Becker, while under the portico of the building can be seen a contemporary abstract composition by Musqueam artist Susan Point titled *Salish Footprint—Welcome Entrance,* representing a school of salmon. These works welcome visitors, on behalf of the Musqueam community, to

facing page :
'Bone Box'
Artist: Michael Nicoll
Yahgulanaas
Haida
2007 · Acrylic, wood
c. 244 × 183 cm · 2696/1 a-l
Museum purchase
(with funds from the Canada
Council for the Arts Acquisition
Assistance program)

Musqueam ancestral territory. In the back of the museum building, on grounds planted by landscape architect Cornelia Oberlander with a mixture of indigenous plants and grasses, are two Haida Houses, ten full-scale totem poles (one inside the larger of the two Haida Houses) and two carved house posts by Susan Point. Perhaps one of the museum's least-known features is that it is aligned along the axis of a World War II artillery emplacement, part of which has been incorporated into the building as the Bill Reid Rotunda. Here, on the museum's site, history, culture and geography are triangulated to provide a cross-section of Canada's most diverse province.

The Museum of Anthropology is unique not only because of its physical setting but because it has created unusually close relationships with cultural communities in British Columbia and around the world through experimental and collaborative research methods and exhibitions. Part of the museum's originality comes from the museum being both a public and a research and teaching museum. The cutting-edge scholarship the museum harnesses makes possible a range of exhibitions and events that cut across traditional disciplinary divisions to provoke creative engagement and dialogue. At the Museum of Anthropology, you are as likely to see an exhibition on surrealism or an exhibit on the way museums have been represented in the movies as you are a world-class exhibition of contemporary First Nations or Asian art. At the time of your visit, a First Nations community or artist group may be using the museum's Great Hall for a ceremonial encounter or a performance. You may come to participate in the global dialogues the museum organizes each year, three evenings of discussions with leading international figures that focus on contemporary issues and problems of worldwide concern. Or you may come simply to enjoy the museum's spectacular architecture and collections. The museum houses 37,000 ethnographic works, 500,000 archaeological pieces and 90,000 historical photographs, many of which originate from the Northwest Coast of British Columbia. Along with giant totem poles, carved boxes, bowls and feast dishes are featured in the museum's Great Hall, while smaller but no less impressive pieces in gold, silver, argillite, wood, ceramic and other materials are exhibited elsewhere in the galleries. The museum's collection includes contemporary and traditional arts from all continents, including significant collections from Asia, the South Pacific, the Americas, Africa and Europe.

Renowned Northwest Coast artists such as Mungo Martin, Bill Reid, Doug Cranmer, Norman Tait, Robert Davidson, Jim Hart and Lyle Wilson have all worked at the museum at one time or another, helping to build the Northwest Coast collections you see today. Bill Reid donated his own works to the museum, and visitors can see the carving tools he used to create iconic pieces of Canadian art, including his monumental sculpture *The Raven and the First Men.*

Contemporary and new media artists such as Michael Nicoll Yahgulanaas, Marianne Nicolson and Sonny Assu are also featured.

The Koerner collection of European ceramics is often described as one of the two most important collections of its type in Canada, and the museum's Multiversity Galleries display collections of Chinese ceramics, textiles, paintings, calligraphy, Hindu stone sculpture and performance arts objects from all over Asia.

The Multiversity Galleries, which opened in January 2010, allow visitors to see work that is usually done behind the scenes at the museum. The first space of their type, the galleries combine high-density storage with displays intended to enhance the viewer's appreciation of the formal and aesthetic qualities of the works, using text and computer-based interpretation. Museum of Anthropology curators collaborate with First Nations communities across British Columbia, as well as with Pacific Islanders, Africans, Asians and Latin Americans, to display the museum's collections. Instead of exhibiting works according to their provenance, usage or type, a practice common to most museums, the Museum of Anthropology arranges works according to indigenous criteria. Some objects are grouped according to the ceremonies in which they were or are used; some are gathered into groups based around their ownership history; some are displayed simply as great art. The Multiversity Galleries embody the idea that there is never just one way of knowing and seeing the world. All cultures and civilizations have developed their own unique criteria, and the museum aims to provide access to many alternative views of "reality."

Back of house, the Museum of Anthropology has one of the most advanced and comprehensive research infrastructures of any museum in North America. In keeping with our commitment to collaborative research, our Community Research suite consists of a recording studio, a laboratory where research on culturally sensitive material can be conducted with appropriate care, special areas for storing precious materials on behalf of families and communities, and a community lounge to help visitors feel at home in what can sometimes seem a strange or ambivalent environment.

The museum's state-of-the-art conservation and research laboratories, our audio-visual studio and workshops, our new archive and library, our peerless archaeological laboratories and our modern storage facilities all provide tools through which works can be preserved, researched and interpreted. The Reciprocal

Research Network, or RRN, is a digital platform that the Museum of Anthropology, the Musqueam Indian Band, the Stó:lō Nation and the U'mista Cultural Society at Alert Bay, British Columbia, have developed with museum partners from across Canada, the United States and England to provide a single-access portal to Northwest Coast collections in all of these institutions. As an interactive system, the RRN has the potential to revolutionize research and to redraw the balance more equitably among communities, knowledge institutions and museums. One First Nations community member referred to the RRN as a form of virtual repatriation. Whether such sentiments become widely accepted or not, the system will give communities access to collections that in some cases few people have previously seen. This development can only stimulate greater creativity and understanding among Aboriginal peoples and Western institutions—and that has to be one of the foremost objectives of all museums in the twenty-first century.

Introduction

This book offers readers a reflective overview of the Museum of Anthropology's diverse collections. It was a challenging task to select the 150 objects featured here from the museum's holdings of more than 37,000, and we had many lively discussions about how to do so. How to arrange these objects on the page was also the subject of numerous discussions, since we recognized from the beginning that the linear format of a book would make it difficult to capture the interplay of ideas and the many relationships that exist among the material cultures represented in a worldwide collection. In the end, each curator has chosen a richly complex array of objects, organized by region, that illustrates the many fascinating journeys these items—marvellous creations of humankind all—have taken to become part of the museum's collections.

The Museum of Anthropology is located on traditional Musqueam territory, and this is where, as a visitor to the museum, your experience begins. As you cross the Welcome Plaza, you are greeted by works created by two Musqueam artists, Joe Becker and Susan Point. To the left of the Welcome Plaza is a house post entitled *Imich Siiyem*—Welcome Good People. The tall figure acknowledges the thousands of years that the Musqueam people have lived in the region, and the image at the base of the post extends a welcome to all the people of the world. Once inside the museum, you cannot miss the entrance to the magnificent Great Hall. As you start down the ramp, the first object you see to the right is the contemporary weaving *Ten* by Debra and Robyn Sparrow, both members of the Musqueam

Indian Band. Once through the Great Hall, you encounter Haida artist Bill Reid's famous sculpture *The Raven and the First Men,* situated in the Bill Reid Rotunda, where many more of Reid's finest creations can be viewed. From there, you enter the Multiversity Galleries, where the museum's worldwide collections are installed. There are many ways to navigate these galleries and view these objects, which span time and space and offer provocative glimpses into the worlds of the makers, the users and the collectors. Some of the objects in the galleries are organized by genre, based on cultural determinants; others are organized according to themes derived from consultations with communities, artists and scholars.

Musqueam territory is also where this book begins. From there, it takes the reader across the continent, making various stops in the Americas before coming to the circumpolar regions. The reader's journey continues on to Europe, then across the waters of the Mediterranean to Africa. Traversing Central Asia and South Asia, the reader travels next to the Pacific, a region that constitutes almost one-third of the world. Ultimately, the journey circles back to the shores of British Columbia, returning the reader to the museum through a visit to the museum's archives. For each object along the way, the reader will find information about its use; its maker, where that person is known; its culture and country of origin; its date of manufacture; the materials from which it is made; its dimensions; and the method by which it entered the museum's collection. The accompanying descriptions capture various aspects of the fascinating story each object has to tell.

The objects depicted in this book are connected to many aspects of life, throughout history and around the world. Many were created to mark occasions and events in the cycle of life—childbirth, child's play, weddings, women's work, men's work, activities such as hunting and harvesting, status and rank, illness, aging and death. These objects depict saints, devils, supernatural beings, ancestral beings. They remind us of uncomfortable truths, sad times, flights from oppression, the revival of lost crafts, the skill of the artist and the need to maintain balance in the world. Sometimes a functional object is also recognized as an object with specific aesthetic value—an expressively carved atlatl, a beautifully designed spindle whorl, an exquisitely woven basket or a finely turned pot. Some objects were knowingly made to be sold to outsiders; others, preserved to be passed on down through a family. The constant movement of people and the trading of goods is seen in Indian textiles worn in Indonesia, Chinese ceramics adopted as family

heirlooms in the Philippines, Afghani dresses made of cloth from Russia, Venetian beads on Cameroon calabashes, silver from Europe in Haida jewellery. Some of the photographs in the book capture work the museum is doing with various communities. Others evoke activities such as performance and music—Cantonese opera costumes, a *budaixi* puppet from Taiwan, a Noh mask from Japan, a *Temes Nevinbur* dance staff from Vanuatu.

Even with all of the complexities represented in these pages, we were constantly reminded in putting this book together that we could never disentangle or convey all of the stories or meanings associated with each object. What we've done instead is to tell the reader some of what we know. By doing so, we hope to open the doors to further sharing.

A Brief History of the Museum

The history of the Museum of Anthropology can be divided into four periods, each equated more or less with the tenure of its successive directors.

The museum's beginnings lie in the University of British Columbia's acquisition of the Frank Burnett collection in 1927. Burnett was a Scottish immigrant who made his fortune in the grain and real estate markets before travelling extensively in the South Seas. He wrote four books based on his travels and put together a fascinating collection of objects. In addition to the Burnett collection, the university counted among its early holdings two important Musqueam house posts, acquired and donated by the UBC graduating class of 1927. A number of totem poles acquired from Marius Barbeau, a pioneer Canadian anthropologist who conducted an early survey of Aboriginal totem poles of British Columbia, and the Buttimer collection of First Nations basketry were later transferred to the museum The curators who presided over this initial period of the museum's history were William Tansley, from 1927 to 1941, and Dr. Ian McTaggart Cowan, who occupied the position from 1941 to 1947. Most of the smaller-scale objects were displayed in a room on the first floor of UBC's main library. The objects were crammed together, but they were catalogued and well organized by the criteria of the day, which meant sorting and grouping them according to their purpose and form.

In 1947, the university hired Dr. Harry Hawthorn, a New Zealand–born Yale graduate, to begin teaching anthropology in the newly enlarged Department of Economics, Sociology, Political Science, Criminology and Anthropology. The

facing page, top:
Frank Burnett's "museum" in the UBC library building, 1927. Photo: Leonard Frank

facing page, bottom:
Gun emplacement at Point Grey Fort, c. 1943. Source: UBC Historical Photographs (1.1/16365)

same year, Hawthorn was appointed director of the museum, and his wife, Audrey Hawthorn, assumed the role of honorary curator. In 1949, under Audrey Hawthorn's direction, the collections moved from the Frank Burnett Room to a larger area in the library's basement. The move meant not only better access and storage for the collections, but space for new exhibits and access to a classroom as well. The latter became crucial in 1963, when the first credited courses in museology and non-Western art were taught.

Harry Hawthorn's interest in the First Nations of British Columbia became the focus of his tenure at the museum. In 1948, working with the British Columbian Indian Arts and Welfare Society, Hawthorn organized a conference that, among other things, sought to create a better understanding of the condition of indigenous art in the province and to ascertain whether art making could be reinvigorated as a source of income for Aboriginal communities. In a move unique for the time, First Nations peoples were invited to this conference to speak about their own communities. That set an important precedent in the development of a more collaborative type of engagement that would, over time, profoundly mark the museum's identity. Harry Hawthorn went on to lead two critical inquiries into the conditions and livelihood of Aboriginal peoples in Canada. The first of these, *The Indians of British Columbia,* was published in 1958, followed in 1967 by his *Survey of the Contemporary Indians of Canada: Economic, Political, Educational Needs and Policies.*

Between the 1950s and the 1970s, the Museum of Anthropology was fortunate to attract two extraordinary benefactors who shared Harry Hawthorn's interest in B.C.'s First Nations. H.R. MacMillan and Walter C. Koerner were both involved in the forestry industry, and their travels around the province brought them into direct contact with First Nations people and their monumental art. Like Harry Hawthorn, MacMillan and Koerner were concerned with the impoverished state of many Aboriginal communities, and they became committed to increasing the visibility of Aboriginal people by collecting the best examples of their art. Both benefactors purchased individual objects and entire collections for the museum, including some that had previously been removed from Canada. Both men also financed collecting expeditions undertaken by the B.C. Totem Pole Preservation Committee and made numerous donations from their personal collections.

The museum's interests were not, however, solely focussed on the Canadian Northwest. From the time of her arrival, Audrey Hawthorn was determined

that the Museum of Anthropology should represent non-Western cultures from around the world, with special emphasis on Asia. Hawthorn encouraged UBC faculty to donate material, and while on leave in England from 1959 to 1960, she made influential connections with curators and collectors that also benefited the museum's growth. Audrey Hawthorn among others long desired a gallery dedicated specifically to Asian art, though funding remained elusive.

The museum's international profile increased dramatically in 1969, when Jean Drapeau, the mayor of Montreal, invited Audrey Hawthorn to curate an exhibition of First Nations art that could be shown in the Man and His World Pavilion, one of the halls built for Expo 67. Following that exhibition, Walter C. Koerner leveraged funding for a new purpose-built museum at UBC from Prime Minister Pierre Trudeau by promising, in return, to donate his personal collections of Northwest Coast art. On July 1, 1971, Trudeau announced a gift of $2.5 million for the construction of a museum to mark the centenary of British Columbia's entry into Confederation. The funding was enhanced by a $1.8 million contribution from UBC. Arthur Erickson, Canada's foremost architect, was commissioned to design and build the museum, and he conceptualized a stunning iconic building completely integrated into its surrounding environment. In 1973, the museum formally assumed the name the Museum of Anthropology at the University of British Columbia, and by 1975, thanks to support from First Nations and the efforts of the Hawthorns, H.R. MacMillan and Walter C. Koerner, nearly half of its total holdings were from the Northwest Coast.

The third period in the museum's history was presided over by Dr. Michael Ames, who became director in 1974. Benefiting from the museum's newly constructed signature building, Ames set about developing a more radically committed program of events and exhibitions. Above all, Ames deepened and widened the museum's political engagement with First Nations that his mentors, the Hawthorns, had begun. His visionary published work, which critiqued traditional museum practices and called for their democratization in favour of the under-represented peoples of the world, aroused a strong current of interest and affected museological thought worldwide. Ames tirelessly documented the ways in which traditional ethnographic museum interpretation was embedded in an entrenched, often inaccurate Western concept of other cultures, and he championed the right of all people to tell their own stories and curate their

own exhibitions. Ames reiterated that art was produced by all societies and cultures, whether those cultures had a specific word for it or not, and he encouraged education as a means of re-empowering the world's poor and marginalized peoples. The early part of his directorship was marked by a varied and experimental exhibition program that touched on all parts of the world, complemented by an equally important active program of performances, which included at one point a Trickster in residence. After a decade or so under Ames's leadership, the museum began to focus more specifically on collaborative and Aboriginally curated exhibitions. Ames's reputation and the work done under his directorship brought the museum international attention as one of the most progressive museums of its kind in the world.

The new museum building included a large, high-density Visible Storage area designed to make the museum's collections available to artists, students, researchers and the wider public. The innovative design of the space, which became renowned internationally, promoted the museum's teaching and research roles while also encouraging artists to engage with the works of their predecessors. In this way, the museum's public, research and teaching functions were transposed onto the building itself, creating a dynamic relationship between the aesthetic exhibit galleries, including the Great Hall and the Masterpiece Gallery, and the more scientific open storage facility in which collections were carefully classified, compared and ordered according to strict museum criteria.

The fourth and current period of the museum's history has been marked by the directorships of Dr. Ruth Phillips, who served from 1997 to 2002, and Dr. Anthony Shelton, appointed in 2004. (Michael Ames returned between 2002 and 2004 as interim director until a new permanent post-holder could be found.) The period has been characterized by a stronger, refocussed vision of the museum as a museum of world art and artifacts, with an emphasis on interdisciplinary approaches to understanding objects in their cultural contexts and on the acquisition and display of contemporary non-traditional Aboriginal arts. During his time as director, Michael Ames had secured funding for an extension to the museum that included a ceramics laboratory, a library, offices and a gallery to house Walter C. Koerner's generous gift of his outstanding collections of European ceramics. Although there was much debate about whether a museum of anthropology was an appropriate setting for such a collection, the acceptance of the gift effectively

dissolved the common division between museums dedicated to European art and culture and their non-Western counterparts. From the outset, the Museum of Anthropology had contested the relevance of the debate between art and science by clearly positioning itself as a museum of world cultures, an orientation that Michael Ames and Ruth Phillips re-emphasized when they acquired two important Asian collections offered by Miguel and Julia Tecson and Victor Shaw. This direction was further promoted by Anthony Shelton, who accepted two unique collections assembled by three UBC professors, Dr. Alfred Siemens and Drs. Blanca and Ricardo Muratorio, that established the foundations for Canada's first permanent exhibition of Latin American art and culture.

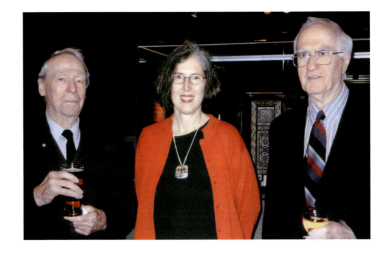

An equally important focus of this recent period in the museum's history is the consolidation of Michael Ames's collaborative approach to museum work and exhibitions. In response to a submission from Ruth Phillips and leaders of the Musqueam Indian Band, the Stó:lō Nation and the U'mista Cultural Society at Alert Bay, the Canada Foundation for Innovation awarded the museum $17.2 million in 2001. This, along with additional funding totalling $55.5 million from the B.C. Knowledge Development Fund, the Koerner Foundation and UBC, contributed to the creation of a new research infrastructure, under the project name "A Partnership of the Peoples," that supports better facilities for collaboration between museums and cultural communities. These state-of-the-art renovations, completed in 2010, have transformed the museum both by giving it one of the most advanced research facilities of its type in the world and by substantially increasing the size of its exhibition galleries and event spaces. The museum today represents the consolidation of a vision that has incubated over sixty years. It is a progressive, open, sensitive and adventurous institution that brings together the world's arts and cultures, promotes dialogue, supports research and encourages visitors to adopt a global perspective on the planet's diverse and increasingly connected peoples.

left to right: Directors Harry Hawthorn, Ruth Phillips and Michael Ames, c. 2004. Photo: Carol E. Mayer

The Collection

The Museum of Anthropology

KAREN DUFFEK

1 The British Columbia Aboriginal Collection

In the Museum of Anthropology's Great Hall stands a weathered, finely carved totem pole from Gitanyow, a village on a tributary of the Skeena River in northwestern British Columbia. Known as the pole of Skim-sim and Will-a-daugh, this monumental sculpture holds many stories belonging to the chief and lineage it represents. Some stories tell of supernatural ancestors, others recount historical events and all document inherited rights to lands, resources and ceremonial privileges. The pole also carries a story about its journey to the museum—the beginning of a relationship that helped shape the institution's approach to collecting, researching and displaying the Aboriginal art of British Columbia.

In 1958, the hereditary chiefs and people of Gitanyow (then called Kitwancool) defined the terms under which they would allow the removal of this and other totem poles by the B.C. Totem Pole Preservation Committee for display in museums. They had not considered it proper previously to sell their totem poles outright. Now, however, they agreed to exchange the historic works under two conditions: that replicas of the poles be made for the community and that the history, territories and laws associated with each pole would be written down by the museum, in collaboration with the chiefs, and then published and made available to students at the University of British Columbia. This agreement was not about salvaging the material evidence of a lost culture. Rather, it marked the decision of a contemporary First Nation to record, and thereby declare, its cultural knowledge and rights as ongoing and belonging to the community's future.

The desire to both salvage existing art and promote the worldwide recognition of Pacific Northwest Coast cultures prompted the museum to build its renowned collection of monumental carvings. The older totem poles and house posts displayed in the museum's Great Hall date from the mid-nineteenth to the early twentieth centuries. Together with the Gitanyow pole, they represent coastal groups from the Musqueam in the south of the province to the Haida and the Nisg̲a'a in the north. Many of these works were acquired in the 1950s through purchase by the B.C. Totem Pole Preservation Committee. At that time it was widely believed, primarily by non-Aboriginals, that Aboriginal art and ceremonial practices belonged to the past and so it was urgent to preserve, for the benefit of the public, what remained. Established by the Museum of Anthropology and the British Columbia Provincial Museum (now the Royal BC Museum), the committee set out to salvage endangered poles from village sites that had been abandoned in the 1880s after the preceding decades of devastating smallpox epidemics, when surviving populations of people gathered in more central locations. Purchases negotiated with owners, band councils and Indian agents were financed by lumber industrialists H.R. MacMillan and Walter C. Koerner, as well as by a number of resource and shipping companies.

Today, visitors from around the world come to admire the massive cedar sculptures in the Great Hall, appreciating them as fine art and as markers of the ancient and continuing presence of First Nations people. For members of the originating communities, the poles are simultaneously works of art, historical documents and cultural teachers. The students and younger generations of artists who come to study the achievements of past masters work with the museum to produce new knowledge and understandings—whether about the distinctions of regional style and artist attribution, or about ways of recognizing cultural ownership and establishing protocols for display. The same dynamic applies to the larger collection of British Columbia Aboriginal materials at the museum, which now includes about 7,800 objects. From the monumental to the miniature, these encompass a diversity of styles, functions, qualities of craftsmanship and histories of ownership and use. Adding to this diversity, and to the vital debates and conversations about art and the representation of cultural heritage, are newly commissioned works in a range of media, from totem poles and weavings to performance art and video installations.

facing page:
Chief Wixha's pole of Skimsim and Will-a-daugh (*left*) stands with other memorial totem poles before clan houses at Gitanyow, 1910. This pole is now in the collection of MOA. Photo: G.T. Emmons, courtesy University of Washington

When the Museum of Anthropology was established in 1947, it received collections already owned by the University of British Columbia. These included the Buttimer collection of 130 Aboriginal baskets and the large Burnett collection of South Pacific materials, with its sixty Northwest Coast objects. Over the ensuing years, the museum purchased, commissioned and received as donations more than 6,000 objects attributed to coastal First Nations and almost 1,700 artifacts from the interior of British Columbia. Because of its relative youth in comparison to long-established museums in Europe, the eastern United States and eastern Canada—many of which sent ethnological collectors to the West Coast in the late

nineteenth century—the Museum of Anthropology holds very little documented pre-twentieth-century ethnological material. However, the Northwest Coast items acquired between 1948 and 1965 form a collection of unique historical significance: the only major museum collection of its kind in the world.

The cultural belongings the museum acquired during those years were often purchased directly from First Nations families or Aboriginal agents, the majority of them with funds from H.R. MacMillan. About 800 were family heirlooms and other items sent to the museum, unsolicited, by their Kwakwaka'wakw sellers. This period followed decades of federal legislation outlawing the potlatch ceremony and more than a century of colonial persecution for Aboriginal people. Family members decided to sell their belongings for a number of reasons, including economic necessity, a desire to keep the objects safe or the family's adoption of new religious beliefs. Often, even when a mask or other object was sold, the inherited privilege it represented remained in the family's possession and could be expressed in newly carved works. Also significant was the presence at the museum between 1949 and 1952 of Kwakwaka'wakw (Kwagu'ł) carver and chief Mungo Martin. Chief Martin was hired to restore totem poles and carve several new ones, and he assisted the museum in documenting its collection. He encouraged Aboriginal families to consider selling their ceremonial pieces to the institution—an act of cultural brokerage critical to the development of the Museum of Anthropology as a museum renowned for Northwest Coast art and also to the creation of a collection with strong, continuing links to its originating families.

MacMillan funds also allowed the museum to purchase about fifteen collections of British Columbia Aboriginal artifacts assembled by missionaries and others. Especially important among those were the Reverend G.H. Raley collection (775 objects, 1948); the Reverend William H. Collison collection (158 objects, 1960); and the Edith Bevan Cross collection (730 objects, 1962). Both MacMillan and his colleague in the lumber industry, Walter C. Koerner, provided cedar logs for the new Haida houses and poles carved between 1959 and 1962 by Haida artist Bill Reid and Kwakwaka'wakw ('Namgis) artist Doug Cranmer, which now stand on the outdoor grounds of the museum.

Walter C. and Marianne Koerner donated their collection of more than 300 historical and twentieth-century Northwest Coast masterworks to the Museum of Anthropology in the 1970s. The Koerners had purchased these objects over many

facing page:
Chief Mungo Martin refinishes the surface of a house post from Fort Rupert as part of a totem-pole restoration project at UBC, 1950. Photo: P. Holburn. MOA Archives

years, primarily from art dealers, with the intent of bringing this heritage back to British Columbia. One of the centrepieces of the museum's contemporary collection is Bill Reid's yellow cedar sculpture, *The Raven and the First Men,* which was commissioned by Walter C. Koerner for the museum and completed in 1980. Other notable donations include Bill Reid's personal donation of 128 objects (beginning in the 1950s), which added to the documentation of Reid's artistic development and helped the museum to build what is now the largest public collection of his art; the Beecher collection of 224 objects (1952); and the Tom and Frances Richardson bequest of more than 120 objects from all areas of the Northwest Coast (1990s).

In recent years, the Museum of Anthropology has added pieces to the collection that strengthen our representation of and knowledge about the art practices and cultural traditions of British Columbia Aboriginal peoples. With the help of individual and corporate donors, as well as of the Canada Council for the Arts, the museum has purchased and commissioned significant contemporary works expressing the diverse perspectives of young artists. Moreover, working together, museum staff and First Nations community members have made the concept of "bridging knowledge communities" a priority, negotiating new pathways through which cultural knowledge about the collections may be stored, maintained and shared for purposes encompassing community needs. Increasingly, too, ceremonial privileges are strengthened as First Nations people research their family's belongings at the museum to restore the place of such "artifacts" in family relationships and ceremony. This ongoing work makes it clear that the value of objects in the museum's collection lies not only in their qualities as works of art but in their connection to what the Nuu-chah-nulth call *kuu-as:* real, living people.

*Object descriptions researched and written by Pam Brown (*PB*), Karen Duffek (*KD*), Jennifer Kramer (*JK*), Bill McLennan (*BM*), Susan Rowley (*SR*) and Ann Stevenson (*AMS*).*

facing page:
Raising of the *Respect of Bill Reid* house-frontal pole carved by hereditary chief Jim M. Hart (7idansuu). The pole was raised on the grounds of MOA in October 2000. Photo: Daniel Robertson

Swoqw'elh (chief's) **blanket**
Artist: Spa'qel'tunaat
Stó:lō, Coast Salish
Late nineteenth to early twentieth century
Wool, goat hair, dog hair, dye
147 × 102 cm · A17200
Museum purchase (National Museum of Canada
Emergency Purchase Fund)

'Ten'

Artists: Debra Sparrow and Robyn Sparrow
Musqueam, Coast Salish
1998–1999 · Sheep's wool, dye
348 × 154 cm · Nbz842
Museum purchase (matching funds
from Canada Council)

Weaving is an ancient Coast Salish art form. Blankets are woven on a large, two-bar loom. In the past, wool was obtained by spinning together mountain goat hair and the hair of a special breed of dog kept in small herds for this purpose. Today's weavers use sheep's wool. Blankets are worn during ceremonies by cleansing dancers as part of their dance regalia and by speakers. Covering someone with a blanket as a gift honours him or her as a person of worth.

The chief's blanket shown on the facing page was worn by Chief Isapaymilt when he travelled in 1906 with a delegation of Coast Salish chiefs to present King Edward VII with a petition declaring that Aboriginal title had not been extinguished. By the early twentieth century, very few blankets were still being woven. Sisters Debra Sparrow and Robyn Sparrow are at the forefront of weavers who helped to revive Coast Salish weaving in the 1980s. *Ten*, the contemporary blanket shown at left, was commissioned in 1998 to highlight Musqueam presence in the museum. (SR)

House posts

Artist: Susan Point (b. 1952)
Musqueam, Coast Salish
1997 · Cedar wood, paint, adhesive, copper
430.5 × 104 × 35.5 cm · Nbz838, Nbz837
Museum purchase (Royal Bank Financial Group
funds and International Forest Products Ltd.)

Anthropologist Harlan I. Smith assembled large collections on the Northwest Coast for the American Museum of Natural History (AMNH) and for the Canadian Museum of Civilization. He collected several decorated house posts from Musqueam. These posts, used inside the house to help support the roof, marked a family's wealth and strength.

When Susan Point was commissioned to carve her own version of two Musqueam posts in the AMNH collection, she interpreted them in a contemporary context. On the post to the left, the water symbolizes the East River of New York City (home of the AMNH); the triangles are the local landscape and the rising sun gently mimics the crown of the Statue of Liberty. On the post at right, the water symbolizes the Fraser River passing by the Musqueam community. (SR)

Ts'la7 (burden basket)
Artist: Kakíhen (Mrs. James Stager)
Lil'wat7ul, Stl'atl'imx, Mount Currie,
British Columbia
c.1920 · Cedar root, canary grass, cherry bark
48 × 38.6 × 31.2 cm · D1.453
Museum purchase

The image on this finely woven basket
has been identified as the mouth-to-
mouth design. How the image originated
is unclear, but since it was passed down
through generations of basket weavers,
it has become an identity marker for the
weaver's family.

When transferred to museums,
artifacts lose their original function.
They do, however, maintain their abil-
ity to divulge the historical knowledge
that was embedded in their creation.
Contemporary basket makers often con-
sult the museum's basketry collections,
keeping their communities' tradi-
tions alive and assisting the museum
in providing better information for
researchers. (BM)

above:
Sawt (Veronica Bikadi, shown at left)
and Metátkwa (Susan Nelson) are mem-
bers of the Lil'wat Nation who teach
and participate in basketry weaving
classes at the Lil'wat7ul Culture Centre
in Mount Currie, British Columbia.
Photo: Bill McLennan

Skagit atlatl (spear thrower)
Swinomish, Puget Sound Salish,
Washington State
1,700 +/- 100 BP (AMS date) · Yew wood
39.4 × 9.5 × 5 cm · A7021
Museum purchase (H.R. MacMillan funds)

The Skagit atlatl, an ancient spear-throwing device, provides an intriguing glimpse into the artistic power, spiritual beliefs and technology of Salish people living in the early years of the first millennium. This weapon survived for 1,700 years, buried in alluvium in the Skagit estuary, until dredged from these silts by a seine fisher's net in 1939. Although some archaeologists initially considered the atlatl apart from local art traditions, recent analysis reveals its affinity with decorated objects created during the same time period and its strong connections to historic and contemporary Salish art. The atlatl's most prominent feature is the magnificent feather-crested lightning snake associated with sea mammal hunting in Salish cosmology. Testing on a replica made by Lyle Wilson for the museum's "Written in the Earth" exhibition showed that the original would have been a very effective hunting tool. (AMS)

Spindle whorl

Quwutsun', Coast Salish
Before 1911 · Wood, lacquer
23.8 cm (diameter) × 2.3 cm · A4323
Mrs. A.J. Beecher Collection

As women sat spinning wool, they were imbuing the yarn with spiritual power. A rod, called a spindle, was placed through a hole in the centre of the disc, or whorl.

The whorl's two sides were shaped differently. The side facing away from the spinner was flat and undecorated. It formed the platform on which the spun wool accumulated in a symmetrical cone. The side facing the spinner was usually curved and sometimes, like this one, carefully carved. The spinner would watch the design turning as she twirled the spindle.

The large bird on this spindle whorl was identified by the collector as a Thunderbird, which plays an important role as a protector of the people. The Thunderbird is chasing a blunt-nosed animal, possibly a wolf. As the yarn built up on the whorl, a perpetual race was run between the two predators. (SR)

Burden basket

Tsilhqot'in

Before 1930 · Cedar root, cedar wood,
fibre, rawhide, cherry bark, cattail grass?
53.1 × 42.8 × 35.7 cm · Nd652
Alfred J. Buttimer Memorial Collection

Basket

Tsilhqot'in

Before 1930 · Cedar root,
cherry bark, cattail grass?
basket 46.4 cm (diameter) × 32.6 cm,
lid 35.8 cm (diameter) × 4.3 cm · Nd623 a-b
Alfred J. Buttimer Memorial Collection

Burden basket

Tsilhqot'in

Before 1930 · Cedar root, fibre,
cherry bark, cattail grass?
41.2 × 32.4 × 27.7 cm · Nd634
Alfred J. Buttimer Memorial Collection

The Museum of Anthropology has a rich collection of basketry from First Nations communities in the interior of British Columbia, in particular from the Tsilhqot'in people. However, most of these baskets were poorly documented by the collector. First Nations weavers and community members work with museum staff, helping to determine the origins of the baskets by their design, shape and style, the stories they depict and the materials the weavers used.

The Tsilhqot'in people are well known for their exquisite coiled basketry. The baskets shown here give us a glimpse of the connection these weavers had to the natural elements in their territories. Decorative designs are made on the surface of the coiled cedar-root basket by adding darker cherry bark or lighter grass strips while the basket is sewn together. The strips are secured to the basket by imbricating, or folding, them under each stitch. Animals, figures and geometric designs, in bands, were worked in, sometimes playfully. People used baskets for carrying, for storage, for cooking and for trade and sale to non-Aboriginals. Today, baskets continue to be valued in First Nations communities for their cultural importance. They are given as gifts, used in trade and offered for sale. (PB)

Canoe

Ktunaxa, Kootenay
c. 1880 · Cotton, paint, bark, metal
700 × 490 × 400 cm · Nd714
Donor: James Dunn

Ktunaxa people have inhabited the Kootenay and Columbia rivers and the Arrow Lakes region of British Columbia for more than ten thousand years.[1] They are renowned for their distinctive "sturgeon-nosed canoes." The boat's unique flat-bottom design tapers at both ends, creating a streamlined shape that cuts easily through the water. Sturgeon-nosed canoes were traditionally made from birch bark, western white pine bark, cedar wood, cedar roots, maple sap and pitch. Their light construction made for easy transport on lakes and marshy wetlands. Today, sturgeon-nosed canoes are made primarily by the Yakan Nukiy people, also known as the Lower Kootenay Indian Band. (PB)

left:
Ktunaxa sturgeon-nosed canoe.
Source: Library and Archives Canada
Credit: E. Van Winkle/PA-122162

Pika-uu (trinket basket)
Nuu-chah-nulth, west coast of Vancouver Island
Late nineteenth to early twentieth century
Grasses, red cedar bark, dye
8.5 cm (diameter) × 7 cm · A2630 a-b
Walter C. Koerner Collection

Nuu-chah-nulth weavers of the west coast of Vancouver Island began creating *pika-uu,* or decorative "trinket baskets," in the mid-nineteenth century. Making baskets for sale to outsiders grew from an ancient practice of weaving whalers' hats and more utilitarian items. Now it became a way for women to participate in the new cash economy. Using *tlii-sikum* (bear grass), *čitapt* (swamp grass), *p̓ic̓up* (red cedar bark) and *t̓ut̓unaxk̓uk* (three-corner grass), weavers perfected a wrapped twining technique to create lidded containers, covered bottles, hats and carrying bags. Motifs depicting whales and whalers, lightning serpents, thunderbirds and even steamships and English words reveal the inventiveness with which weavers honoured Nuu-chah-nulth cosmology and took hold of new ideas.

Most of the older baskets in the museum were collected without recording their makers' identities. Research continues today with community members and through archival records to reweave these strands of cultural knowledge and history. (KD)

Teka'mɫ (whaling harpoon point)
Nuu-chah-nulth, west coast of Vancouver Island
Late nineteenth century
Iron, elk horn, spruce resin, sinew, wood
24 × 7.6 × 4.8 cm · A9096

Hishuk ish tsawalk expresses the Nuu-chah-nulth philosophy that "everything is one." This harpoon point maintains that ongoing connection to an ancient and still evolving complex of whaling practices, to territorial rights and to knowledge of the natural and spiritual worlds.

The Nuu-chah-nulth and their neighbours to the south are the only Northwest Coast peoples to have hunted the great humpback and grey whales from canoes on the open Pacific Ocean. With a single thrust of his harpoon, a skilled whaling chief could pierce the tough skin of his prey and inflict a mortal wound. Rigorous training, preparatory rituals and specialized equipment—including yew-wood harpoons, sinew lanyards, sealskin floats, cedar-bark lines and magic charms—were critical to the success of the whaler and his crew. Even the barbs of this harpoon point are engraved with powerful motifs: images of lightning serpents, which served as helpers to the greatest whaler of all, the thunderbird. (KD)

The Klix'ken (Sea Lion) House

Artists: Siwis (George Nelson) and Quatsino
Hansen; commissioned by Tza'kyius
Gusgimukw, Kwakwaka'wakw,
Xwatis Village, northern Vancouver Island
c. 1906 · Red cedar, paint
4.4 m (house posts and figure);
5 m (crossbeam) · A50009 a-f
Collected for UBC by the B.C. Totem Pole
Preservation Committee (H.R. MacMillan funds)

Sometime around 1906, the Klix'ken, or Sea Lion House, was built in Xwatis village, deep inside Quatsino Sound on northern Vancouver Island. By this time, Aboriginal peoples along the coast had largely replaced their traditional cedar lineage houses with Victorian framed houses of milled lumber. Klix'ken House was the last old-style dwelling erected in Xwatis. Although it featured a modern exterior with milled-lumber front and three windows around the door, its interior revealed a monumental post-and-beam structure with carved symbols of the family's history and wealth.

Tza'kyius was the owner of this great house and of the sea-lion crest after which it was named. Two large sea-lion house posts carved by Quatsino Hansen stood inside the front door, supporting a crossbeam said to represent a double-headed sea lion. The other end of the ridge beam spanning the length of the house was held up by the head of a figure, carved by George Nelson, that depicts a powerful transformer being—a founder of the lineage. With copper shields painted on his arms, pieces of copper (now missing) attached to his chin, a sea-lion or whale head emerging from his chest and two slaves holding up the ceremonial bench before him, this imposing ancestor figure makes visible the Kwakwaka'wakw concept of the house as a sacred entity: an embodiment of the lineage and its supernatural origins. (KD)

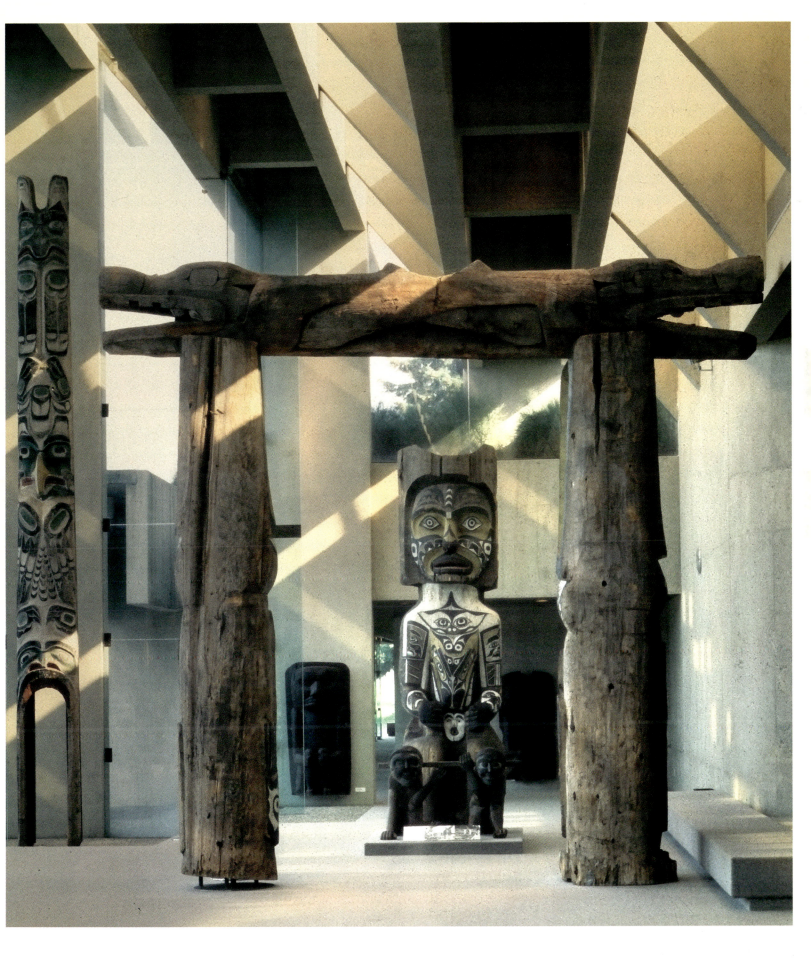

Hamsalagaml (bee mask)

Artists: Willie Seaweed (c. 1873–1967)
and Joe Seaweed (1910–1983)
'Nakwaxda'xw, Kwakwaka'wakw,
Ba'as (Blunden Harbour), Central Coast
c. 1948 · Yellow cedar, cedar bark, cord, paint
Museum purchase

top left:
Artist: Willie Seaweed
50 × 18 × 13.9 cm · Nb3.1364

top right:
Artist: Joe Seaweed
44 × 21 × 11 cm · Nb3.1361

bottom left:
Artist: Joe Seaweed
51.5 × 16 × 13 cm · Nb3.1362

bottom right:
Artist: Willie Seaweed
47 × 17 × 14 cm · Nb3.1363

Although their wooden stingers are now missing, it is easy to imagine how these lively bee masks would cause much laughter and commotion in the ceremonial *Gukwdzi,* or Bighouse. The four dancers would flit around the floor to a rapid drum beat, "stinging" people who were rewarded with special gifts.

The *Hamsalał* dance is an inherited privilege passed down within a family. This set of masks was commissioned by their original Ma'amtagila Kwagu'ł owner during the period of potlatch prohibition (1884–1951), when their use in ceremony was still deemed illegal by federal legislation. They were danced on several occasions before being offered for sale to the museum. Their purchase price included a new set of masks commissioned from a contemporary Kwagu'ł artist. This has allowed the family to continue to display its privilege in ceremony. (KD)

'Coke Salish'

Artist: Sonny Assu (b. 1975)
Ligwiłda'x̱w, Kwakwa̱ka̱'wakw
2006 · Duratrans and light box
96.6 × 55.8 × 17.7 cm · 2674/1
Museum purchase

Vancouver-based artist Sonny Assu creates work in a range of media—painted hide drums, digital prints and installations—to explore the ways that popular and consumer cultures intersect with Aboriginal experience and representations. Humour and irony tend to be at the forefront of his art. The installation of *Coke Salish* at the museum caused some concern among visitors, especially those unable to find the soft-drink machine the sign seemed to advertise. Those who got the joke were led to reflect on their own relationship to the cultural and corporate totems the piece subverts.

As Sonny Assu explains, "*Coke Salish* uses the iconic pop-cultural script to illustrate the fact that everyone in Vancouver and the Lower Mainland inhabits the traditional territory of the Coast Salish people. It pays homage to the people whose land we live on and, through a tongue-in-cheek political statement, helps people understand the territorial issues of today." (KD)

37

Kangextola (button blanket)

Mamalilikala, Kwakwaka'wakw

Before 1953 · Wool, cotton, shell, plastic

183 × 130 cm · A4251

Museum purchase (H.R. MacMillan funds)

Button blankets are a respected, essential element of contemporary Northwest Coast ceremonial regalia. In existence since at least the mid-nineteenth century, and made of materials acquired from the Hudson's Bay Company, the blankets were a later version of traditional fur robes, woven Chilkat and Raven's Tail robes and cedar bark capes trimmed with fur. They are worn on ritual occasions to display identity and rank. Today their use has expanded to encompass political protest and the display of Aboriginal dignity and pride at national and international events.

Typically, a button blanket depicts its owner's family crest, which is represented in appliquéd cloth highlighted with mother-of-pearl or plastic buttons, sequins, paint, metal or abalone shell, and is trimmed with a deep, contrasting-coloured border. This particular button blanket has a predominant crest of the Kwakwaka'wakw at its centre: the *kwaxalikala,* or "Tree of Life" design. (JK)

Imas (ancestor) **transformation mask**
Kwakw<u>aka</u>'wakw
Early twentieth century
Wood, cedar bark, leather, paint, metal
61.6 × 32.2 × 28.2 cm · A17140
Walter C. Koerner Collection

Kwakwaka'wakw *Imas* masks tell the stories of founding ancestors who descended from the myth world in the skins of animals and transformed into humans. A mask is shown at the beginning of the *Ṫseka* (winter ceremonial, or red cedar bark ceremony), during which the deceased carrier of the ancestral name it represents, a high-ranking chief, comes back one last time to pass on his rights and privileges.[2] This particular *Imas* mask depicts the ancestor Nulis,[3] who came down in the guise of a grizzly bear at Wakanukw, located on Tribune Channel in Knight Inlet. The mask's dance re-enacts the historic event when the holder of the Nulis name, with the help of his crest figure, the supernatural bear, vanquished a *sisiyutł* (double-headed sea-serpent) who was damming the river, blocking access to the salmon and other resources.

This mask is one in a series produced for the carrier of the Nulis name. For the Kwakwaka'wakw family that holds this name and prerogative, the physical mask is only a stand-in for the privileges it embodies, and it can be replaced as need be.[4] (JK)

Bear rattle

Dzawadạ'enuxw, Kwakwạkạ'wakw
(Tlingit origin?)
c. 1850 · Hardwood, copper wire, paint
26.7 × 17.8 × 15.2 cm · A6095
Museum purchase (H.R. MacMillan funds)

Acquired from a Kwakwạkạ'wakw owner, this rattle is a classic northern artifact in its carved and painted style. How it travelled down the coast to Kwakwạkạ'waka territory is unknown. Because of its uniqueness in the Kwakwạkạ'wakw community, this rattle likely carried a status equal to that it held in its originating community, possibly even greater.

For the museum, there is some question about where this rattle should be placed when it is exhibited. Its social context of use has been changed by its arrival at the museum. Aesthetically, the rattle's carved and painted details lead experts in the field of Northwest Coast art to speculate that its origin of manufacture may be Tlingit or Tsimshian. Eventually, pigment testing may yield physical evidence about the culture of manufacture. However, since pigment was a trade item among Northwest Coast communities, arguments concerning the rattle's origin will continue. (BM)

Paddle

Artist: Daniel Houstie

(c. 1880–1912; attributed)

Heiltsuk

Wood, paint

133 × 14.4 × 3.2 cm · 1768/100

The Tom and Frances Richardson Collection

Paddle

Artist: Captain Carpenter

(1841–1931; attributed)

Heiltsuk

Late nineteenth or early twentieth century ·

Yellow cedar, paint, lacquer

158 × 14 × 4 cm · A1492

Museum purchase (H.R. MacMillan funds)

Canoe paddle

Artist: Daniel Houstie (c. 1880–1912)

Heiltsuk

c. 1900 · Wood, paint

133.5 × 14.4 × 3.2 cm · Nb3.1484

The Tom and Frances Richardson Collection

These Heiltsuk canoe paddles were probably made to be sold to non-Aboriginal collectors. Such works represent one of the last forms of painted art created by artists trained in the late nineteenth century. Producing souvenirs became a way for painters to continue their traditions during a time of great cultural change.[5]

Daniel Houstie was a Heiltsuk artist whose replicas of traditional objects were among the items collected by missionary R.W. Large for the Ontario Provincial Museum between 1898 and 1901.[6] Captain Carpenter, a member of the 'Qvuqvayaitxv tribe, was born in the Heiltsuk village of 'Qvuzvai in 1841.[7] He belonged to the Blackfish clan and had the privilege of representing his family's crest—an eagle (from his mother's side) over a killer whale (from his father's side)—on traditional ceremonial regalia and other carved and painted items.[8] Although he never signed these works, his distinctive style is easily recognized. (PB)

Qpîálás šáwáçi (bentwood chest)
Heiltsuk, Central Coast
Nineteenth century · Wood, paint, metal tacks
82.5 × 51 × 50 cm · A8211 a-b
Museum purchase (H.R. MacMillan funds)

The idea of the container as a living being—and the living being as container—is embodied by the elaborate storage chests used by Aboriginal peoples of the central and northern Northwest Coast. These chests and boxes held the tangible wealth of high-ranking families: the regalia, masks, blankets and other treasured property that proclaimed both history and privilege. Created by specialist artists, the finest containers were often passed down as heirlooms through generations of a family or were circulated as valued trade items. They were constructed by an ingenious process unique to Northwest Coast cultures, in which the sides of the chest were grooved, steamed and bent from a single plank of cedar. Most chests share a common motif, depicted with endless variations, that feature an enormous face with doubled eyes. It is said to represent the sea-monster chief: a powerful, transforming creature that controls and protects wealth. It was collected in Duncan, British Columbia, from Chief Charlie Solwheymault, Quwutsun'. (KD)

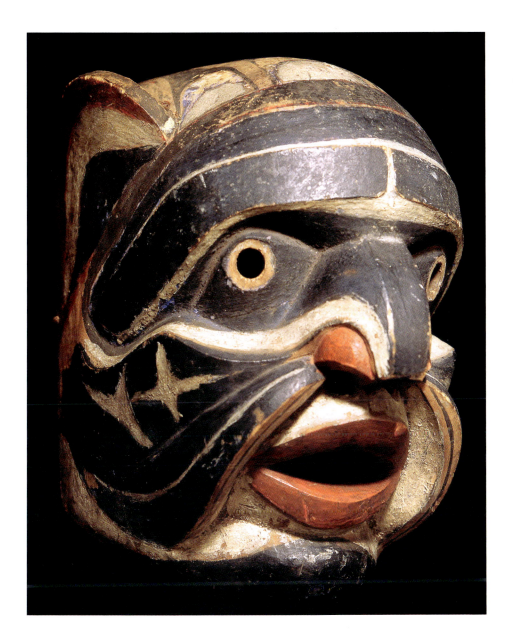

Q'umukwa (undersea chief) **mask**

Nuxalk, Bella Coola

c. 1880–1900 · Alder wood, paint, fibre, nails

36 × 27 × 25 cm · 1611/1

Museum purchase

This mask depicts the supernatural being Q'umukwa, the Nuxalk name for "Chief of the Undersea World" or "Wealthy One." The mask is usually shown during a *sisawk,* or chief's ceremonial, in which families display their rights to status, wealth and power by representing *smayustas,* ancestral origin stories, in dance and song. It is said that Q'umukwa lives beneath the ocean in a house made of copper, wears an enormous hat and has authority over all undersea creatures.

The Nuxalk Tallio people from South Bentinck Arm have a *smayusta* that tells of a young male ancestor worried he will not live up to the fame of his father. He goes away to pine and sees *Q'umukwa*'s house rise up out of the water. The young man is invited in by a seal, witnesses the sea creatures dancing and is given supernatural rights and privileges. When he returns home, he builds a replica of the copper house in his village and becomes a highly respected chief.[9, 10] (JK)

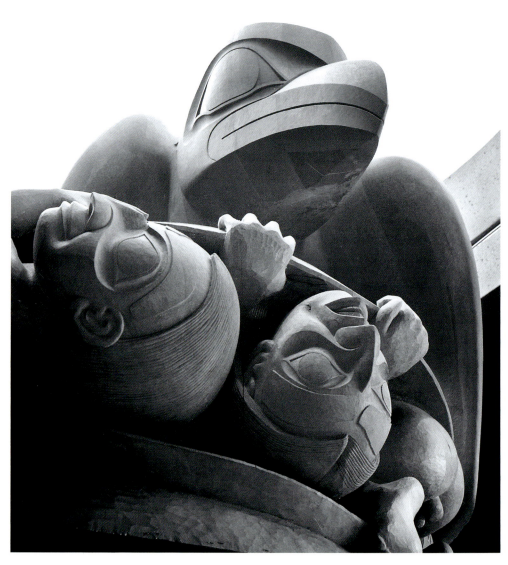

'The Raven and the First Men'
'The Raven Discovering Mankind in a Clamshell'

The story of the Raven and the First Men inspired these two sculptures by Bill Reid. Reid wrote his own version of the story and narrated it in 1976 during a slide presentation at the museum. Here is an excerpt:

"It was quite some time ago [that] the Raven, the Trickster, greedy, gluttonous, lustful, capricious and powerful, stood on the beach at the place we now call Rose Spit on the Queen Charlotte Islands. For a change he wasn't hungry. He had stolen the light from its box in the house in the middle of darkness and scattered it through the sky. Now the sun shone on the long beach curving all the way to Tow Hill, beautiful, empty, lifeless, nothing to challenge his insatiable restless curiosity. He walked impatiently along the water's edge, scratching at the sand, looking to all sides for something to relieve his boredom. His shiny black head cocked as he listened for any unusual sound.

"And then, in a pause between the rustle of the waves, he heard it. A little twittering, squeaky sound, muffled, seemingly far away. The Raven looked intently all around and saw right at his feet a flash of white.

"He looked closer, and there was an enormous clamshell half buried in the sand, and in it some little creatures, panic-stricken in his giant shadow, trying desperately to hide, and crying in their tiny voices. Well, here was a moment of diversion, a new phenomenon to help pass the time, but it wasn't very interesting as long as the creatures stayed in the clamshell. So he leaned close. He began to talk to them, to tell them to come out and play in his big new world.

"We don't know and can't guess what lies and blandishments the Raven used to coax the little shell dwellers to emerge, but he wasn't called the great Trickster for no reason. And in time, first one, then another tentatively ventured out—often to turn right around again when they saw the vastness of the sea, the beach and the sky—and retreat to the safety of the shell.

"But eventually they scrambled into the light, and the Raven saw that they were strange creatures, two-legged like himself. But there the resemblance ended: no glossy feathers, no powerful wings, no thrusting beaks. Instead, pale naked skin, frail, stick-like appendages that waved and fluttered continuously, round flat-featured heads, in other words, men: the first humans in that part of the world, the male ancestors of all who would come after them... There were no women in the clamshell, and so the Raven had another task to perform in order to properly begin the play in what was to be his greatest game. But that's another story, and one which still goes on." (BM)

Panel pipe
Haida, Haida Gwaii
c. 1850 · Argillite
41.7 × 8.8 × 0.9 cm · A2572
Walter C. Koerner (Masterpiece) Collection

Argillite is a form of slate that is obtained only near the community of Skidegate on Haida Gwaii. There is little evidence that argillite had a cultural use prior to the coming of the Europeans in the late eighteenth century. Carved into figures of Europeans, ships and animals that incorporated Haida imagery, it became a trade item bartered between Haida carvers and sailors on the trading ships, who then resold the pieces in Europe and eastern North America as curios.

This panel pipe has a hole drilled at one end to accept a pipe stem and a hole on top to accept the pipe bowl. The intricate, masterful carving in this work depicts the rigging of a sailing ship with block and tackle, hooks, deadeyes and lanyards. Two sailors and two dogs are seemingly suspended in the rigging, possibly documenting a real-life event. (BM)

'Hole in the Ice Totem Pole, the House of Haidzemerhs at Gitanyow'

Photographer: Wilson Duff
Gitanyow, northwestern British Columbia
1957 · 35 mm Kodachrome transparencies
MOA archives collection

On-site photography documents the changes that take place in communities. On the Northwest Coast, photography has had the additional value of providing a reference for artists and communities rebuilding their traditions. The pole shown in these photographs by Wilson Duff, located in Gitanyow village in northwestern British Columbia, was taken down in 1991 due to concern for its strength and stability, and it now resides in the Museum of Northern British Columbia. The components of the house depicted here were not saved, but the photographs reveal enough information about its construction that a very accurate copy could be made if so desired.

Wilson Duff was a curator at the Royal British Columbia Museum from 1950 to 1965, later coming to the University of British Columbia as a professor teaching Northwest Coast art and history. His research and photography is housed in the museum's archives and the UBC Library, Rare Books and Special Collections. (BM)

Male and female masks

Artist: Skil kew Wat
(Freda Diesing; 1925–2002)
Haida
1973 · Alder wood, human hair,
cedar bark, paint, fibre
left to right: 25 × 23 × 14 cm;
31 × 25 × 13 cm · Nb1.720; Nb1.721
Museum purchase

In these two contemporary carvings, Freda Diesing has captured the essence of a classic Northwest Coast mask. Her fine craftsmanship creates elegant shapes in a powerful visage of the human face. Strong, simple forms are essential elements in masks meant to be danced by firelight. Masks were, and continue to be, used in potlatches to represent family prerogatives and ancestors. The female mask shown here has a labret in the lower lip, an indicator of high status. The male mask has a goatee.

Freda Diesing is recognized for her artistic accomplishments and her role as a mentor to a generation of artists working to re-establish the traditions of Northwest Coast art. In 2002 she received a National Aboriginal Achievement Award, and she has also been awarded an honorary doctorate by the University of Northern British Columbia. (BM)

'The Last Haida Potlatch'

Photographer: W.H. Collison (possibly)
Haida, Skidegate
c. 1900 · Sepia print
18 × 13 cm
MOA archives collection

The Canadian government attempted to assimilate the societies of the First Nations of British Columbia by passing legislation banning the potlatch in 1884. The law had been requested by Christian ministries trying to build "new" First Nations communities and by those interested in extracting the rich resources such as furs, fish and lumber.

This photograph is thought to have been the idea of the Anglican minister in Skidegate, W.H. Collison. The plan was to take one last photo, then declare an end to the potlatch. Participants have their faces painted to denote clan affiliation. The two people standing on the upper left wear paper masks to symbolize masks originally carved from wood. Some of the individuals have been identified. Daniel Young is at the far left, holding the speaker's staff. Behind him are his son Henry Young and Moses Gold (in the white tie). Tom Price, chief of SGaang Gwaay Llnagaay (Ninstints), is on the far right in the white shirt. In the seated row of women, Lizzie Bell is on the far left. (BM)

Xiigya (bracelet) **with beaver**
Artist: Charles Edenshaw (c. 1839–1920)
Haida, Haida Gwaii
c. 1890 · Silver
18.3 cm (circumference) × 2.7 cm · Nb1.742
The Tom and Frances Richardson Collection

Metal has been used on the Northwest Coast for at least two thousand years. Copper, found as natural nuggets, was reformed with heat and stone hammers into arrowheads, blades and decorative items such as ear pins and anklets. Metals created through smelting, such as iron and steel, arrived on the coast from Asia (at least eight hundred years ago) both through trade and in pieces attached to drift wreckage. These metals were also re-formed into tools and decorative items. Silver and gold arrived with the European explorers, first as trade and later as coin currency paid to Aboriginal labourers who were cannery and sawmill workers.

Gold and silver bracelets were created by hammering a coin into a bracelet shape, then engraving a family crest or Victorian scroll motif into the metal. High-ranked women might wear several bracelets on both arms. Eventually a market developed for "Northwest Coast" bracelets in the European population, a market that still exists and continues to grow. The bracelet shown is by the most noted engraver of the time, Haida artist Charles Edenshaw. (BM)

Txaldzap'am nagyeda laxa
(carved angel) **baptismal font**
Artist: Frederick Alexcee
(1857–1944; attributed)
Tsimshian, Lax Kw'alaams
1886 · Hardwood, paint
82.5 × 62.5 × 60.6 cm · A1776
Museum purchase (H.R. MacMillan funds)

With its Christian motif created by a
Northwest Coast artist, this carving
illustrates the reverence required of
those who converted to the new religion.
According to its unofficial folk his-
tory, this sculpture scared the children
as they came into church, so it was put
into storage. The carving was acquired
by the Reverend G.H. Raley, who attrib-
uted the work to Frederick Alexcee, an
artist of mixed Tsimshian/Iroquoian
descent. Alexcee is better known for his
paintings, done in a realistic style, and
for smaller carved works made for the
art market. Since there are no other large
carvings attributed to Alexcee, it has
been suggested that this carving was
actually done by an artist of an earlier
generation, someone more familiar with
large-scale carvings and the carving of
traditional masks. (BM)

Smgan hoyt a txaldzapgit a txa'aga waap (house screen plank)

facing page, left:
Tsimshian, Lax Kw'alaams
c. 1800 or earlier
Cedar, hematite pigment, magnetite pigment
359 × 67 × 3 cm · Nb7.240 a-b
Museum purchase (H.R. MacMillan funds)

facing page, right:
Detail reconstructed from raking light
photography. Photo: Bill McLennan

The art of the Northwest Coast is recognized as distinctive and world-class—in particular, the northern style of painting, which is calligraphic in nature, with expanding and contracting lines connecting to create elegantly balanced positive and negative spaces. Composition follows a highly developed system of formal conventions that are assembled to create an overall image.

This plank is one of five in the museum's collections possibly from the same painted screen. The plank was split from a red cedar tree, with the front surface knifed smooth to create a surface for fine painted lines. Along the edge of the plank are holes through which cedar withe was threaded and sewn to other planks, making a larger panel. A number of these panels would have been placed together to form a screen, and the screen placed on the front of a house to show the family's crests and history during a potlatch.

This plank, originally one piece, had been split in two by the time the museum acquired it. Part of its top, and possibly its bottom, had been cut off. The original screen could have been as high as five and a half metres at the centre and fifteen metres wide. Mineral-based pigments were likely combined with chewed salmon egg to create the paint. Weathering had eroded the plank's surface, but the wood underneath the pigment was better protected. Light raked across the surface of the boards, combined with high-contrast photography, revealed an elegant painting at least two hundred years old, the oldest known example of this kind. (BM)

Scoop for oolichan oil

Nisg̲a'a

Nineteenth century · Hardwood, paint

38 × 17.5 × 9 cm · A6191

Museum purchase (H.R. MacMillan funds)

Oolichan are a small fish, members of the smelt family. Since they are the first fish in spring to migrate up the coastal rivers, they were often referred to as "saviour fish," bringing nutriment after a long winter. Oolichan are dried, smoked and processed for their oil. The oil, a very important trade item among First Nations communities, is a rich food supplement that is also used to preserve and store berries, crabapples and other perishable foods. Although the fish has not been commercially harvested, it is in decline, with some coastal runs now considered extinct.

To produce the oil, also known as grease, freshly caught oolichan are left to ferment in large bins for seven to ten days. They are then transferred to wooden boilers, heated over a fire and stirred. The resulting "soup" is then allowed to stand, so that the oil can float to the surface. Often, cold water is carefully poured in along the edge of the container to aid the process. The oil is then skimmed off into other containers for storage and transportation. (BM)

Gwiis halayt

(chief's blanket and leggings)

Nisg̱a'a

Nineteenth century

Museum purchase (H.R. MacMillan funds)

Blanket

Mountain goat wool, linen, jute,
cedar bark, dyes, otter fur

185 × 134.5 cm · A7079

Leggings

Mountain goat wool, sheep skin,
cedar bark, dyes, cotton, copper

43.5 × 34.5 cm · A7078 a-b

According to W.E. Collison, son of
Anglican missionary W.H. Collison,
this blanket and leggings were owned
by Chief Kitex, the last of the Nass
chiefs to accept Christianity. The
designs on blankets and leggings com-
municated the rank and prestige of the
owner. The design on the blanket rep-
resents a crest image, though it is not
easily deciphered. The leggings were cut
from other blankets, likely as part of a
potlatch ceremony.

Weaving blankets from mountain
goat wool mixed with shredded cedar
bark is an ancient and complex tradi-
tion. The techniques were kept alive
by the Tlingit, who acquired weaving
knowledge through marriage with the
Tsimshian. In recent years, weavers
from other coastal communities have
relearned the techniques, using sheep's
wool with cedar, to produce modern
versions for use in ceremony. (BM)

facing page:
'The Messenger'
Artist: Dempsey Bob (b. 1948)
Tahltan / Tlingit
2000 · Bronze
47.4 × 36.6 × 25.7 cm · 2648/1
Museum purchase (matching funds from
Canada Council for the Arts Acquisition
Assistance program)

Dempsey Bob uses wood carving, draw-
ing, print making, dance and song to
honour his Tahltan / Tlingit cultural
tradition. His bronze sculptures exhibit
his characteristic meticulous crafts-
manship and finish. With this piece in
particular, he extends and transcends
his immediate cultural heritage, in the
way of great artists. "I got into bronze
because I needed another challenge,"
Bob said in 2000. "After you've made a
thousand pieces out of wood you have to
change, and bronze gave me that change.
Bronze has a different feeling to it, it's
new and it's a challenge to make it good.
Our art has to grow. What I'm trying to
do is make the art real today for our
people and for myself too."[11] The
museum's collection of contemporary
Aboriginal art explores this traditional-
contemporary duality. (PB)

above:
Lax aak (soul catcher)
Gitxsan
c. 1850 · Bone
18.7 × 3.9 × 2.4 cm · 1100/1
Donor: Marjorie Jean Finlayson in memory
of Reginald William Finlayson

According to oral tradition, a soul
catcher was made from the shin bone
(femur) of a grizzly bear. It was worn
around the neck and used by the *Halayt*
(shaman) to capture and return souls
that had left the body, thus causing ill-
ness. Originally, cedar bark plugs were
used in the openings at either end to
contain the spirits or souls. (BM)

Chilkat bag

Tahltan

Before 1880 · Mountain goat hair, cotton,
yellow cedar bark, glass beads, wolf moss dye
66 × 18.7 × 2.2 cm · A2.529
Museum purchase (H.R. MacMillan funds)

This Chilkat bag, made from a blanket,
was featured in *Mehodihi: Well-Known
Traditions of Tahltan People,* a collab-
orative exhibition mounted by the
Tahltan Nation and the Museum of
Anthropology in 2003. According to
Dempsey Bob, a Tahltan-Tlingit art-
ist, "Traditionally Chilkat blankets were
used by chiefs, and the clan house lead-
ers. Chilkat blankets were very spiritual.
Certain clans referred to their hats,
masks and blankets as clan treasures.
Sometimes at a potlatch, they would
cut a blanket and they would distribute
those pieces in the potlatch. The pieces
would go to the clan leaders of the oppo-
site clan. They would use these pieces
sometimes for their regalia. This piece
to me is part of the Chilkat and someone
decided to make a bag out of it. What
I like about it, the bottom part of it is
really Tlingit Chilkat style, and the top
is Tahltan—a very traditional, classic
Tahltan style of beading, colour and use
of the design."[12] (PB)

Notes

1. Harry Holbert Turney-High. *Ethnography of the Kutenai*. Menasha, WI: American Anthropological Association, 1941; New York: Kraus Reprint Co., 1969, p. 69.

2. Franz Boas. *The Social Organization and Secret Societies of the Kwakiutl Indians*. Smithsonian Institution Annual Report for 1895 (1897), p. 358.

3. Wedlidi Speck. *The Story of Nulis*. n.p., n.d.

4. Personal communication with William Wasden, Jr., July 11, 2008, and with Edwin Newman, July 11, 2008.

5. Bill McLennan and Karen Duffek. *The Transforming Image: Painted Arts of Northwest Coast First Nations*. Vancouver and Toronto: UBC Press; Seattle: University of Washington Press, 2000; Vancouver and Toronto: Douglas & McIntyre, 2007.

6. Martha Black. *Bella Bella: A Season of Heiltsuk Art*. Toronto: Royal Ontario Museum; Vancouver and Toronto: Douglas & McIntyre; Seattle: University of Washington Press, 1997, pp. 119–20, 162–63.

7. Pam Brown. "Searching for Du'kwayella." Unpublished paper, Museum of Anthropology, 1992.

8. Ronald L. Olson. "Notes on the Bella Bella Kwakiutl." *Anthropological Records* 14, no. 5 (1955): 319–48.

9. Clyde Tallio. Personal communication, August 11, 2008.

10. Franz Boas. *The Mythology of the Bella Coola Indians*. New York: American Museum of Natural History, 1898, pp. 51–52.

11. Tanya Bob. *The Art Goes Back to the Stories: An Exhibition on the Work of Dempsey Bob, Tahltan/Tlingit Artist*. Vancouver: Museum of Anthropology, 2000.

12. Pam Brown. *Mehodihi: Well-Known Traditions of Tahltan People*. A Collaborative Exhibition by the Tahltan Nation and the Museum of Anthropology, 2003.

2 The North American Collection

Anthropologists frequently divide North America into ten regions, or "culture areas." The idea underlying this concept is that groups within a culture area will have more similarities with one another than with neighbouring culture areas. The Northwest Coast and the Arctic are presented elsewhere in this book, leaving the Sub-Arctic, the Plateau, the Plains, the Great Basin, California, the Southwest, the Eastern Woodlands and the Southeast to be covered in this section. These eight cultural areas exhibit great diversity in way of life, worldview, physical environment and history of encounters with Europeans. Indigenous groups situated on the east coast of North America were the earliest to be affected by contact with Europeans. Some of the material culture from this early contact—artifacts and other human-made objects—made its way to Europe, where it appeared in the *Wunderkammer,* the Cabinets of Curiosity, of nobles and royalty. These were the foundation for many of Europe's great museums.

Within the Museum of Anthropology's own North American collection, there is a steep drop in the number and size of the collections the farther east and south one travels across the continent. This is due to several factors. The first of these is the mandate of the museum—to focus on the cultures of the Pacific Northwest Coast. The second factor is the tendency of collectors to amass items that are "in vogue" at particular times. Two examples were the rush to collect items from the Northwest Coast at the end of the nineteenth century and a similar focus on Inuinnait (Copper Inuit) items in the early twentieth century. When First Nations

people from the Plains became the stereotype of the "North American Indian," items from those cultures were also heavily collected.

Most of the items in the Museum of Anthropology's North American collection were already part of a family, museum or individual collection when the museum acquired them. Only a few, including a small collection of Southwest pottery, were expressly collected for the museum. Individual collectors fall into three categories. The first are people who become fascinated with a particular item of material culture. These collectors build their collections over a long period. They become experts about the items they collect and frequently form societies or even small community museums. Mrs. A.J. Beecher's basketry collection was well known around the turn of the twentieth century. Not only did Mrs. Beecher keep a detailed catalogue of her holdings, she also wrote short texts on card stock to accompany the baskets when they were displayed for visitors.

The second group of collectors are travellers who buy gifts to send back home. One example of this type of collector was A.A. Kingscote. As a young RCMP officer on the Plains in the early 1920s, Kingscote sent his mother small items he thought would appeal to her—rosettes and other items of beadwork. He later donated this collection to the Museum of Anthropology in memory of his mother.

Still other collections are personal mementos. These items, brought back as souvenirs, often remain in one family over generations.

From the mid-1800s until the 1980s, residential schools were operated across Canada by church organizations with financial support from the federal government. In 1920, the Canadian government enacted legislation that made it mandatory for First Nations parents to send their children to residential school. Children as young as six were taken from their families and placed as wards of the state in these church-run institutions. Underlying the residential schools was an explicit policy of assimilation. Students were forbidden to speak their own languages, and punishments for transgressions were harsh, even by the standards of the time. Children living in the residences often saw their families only once a year, so that not only their language was stripped away but also their participation in family life and spiritual culture. Many became strangers in their own land, at the same time being rejected by Canadian society. It is only recently that former students have begun to talk openly of the physical and sexual abuse they suffered at many of these schools. In 2007, the federal government and First Nations

agreed to the Indian Residential School Settlement, which provides payments to residential school survivors and funds memorials and a Truth and Reconciliation Commission. In 2008, the federal government issued a formal apology to Aboriginal people. The Museum of Anthropology is fortunate to have several collections that serve as reminders of the residential school period.

Object descriptions researched and written by Susan Rowley (SR) *and Anthony Shelton* (AS).

Morley Indian Residential School, 1931–1934. Jean Telfer Fonds, MOA Archives

Hide scraper

Artist: Baptiste Betsedea

Dene, Northwest Territories

1981 · Spruce wood, stone, fibre, metal, dye

93.5 × 10.5 × 7.5 cm · Na1683

Museum purchase (field collected)

Stone tools are often associated with the distant past. However, for some activities, such as hide scraping, stone is still sometimes the material of choice. In 1981, Baptiste Betsedea, walking along a river in the Northwest Territories, found a stone flake he recognized as ideal for a scraper. He chipped the edges to create the appropriate angle of use, drilled a hole in it, and attached it to a spruce pole with a metal nut and bolt, nylon cordage and a J-cloth. The scraper was then used to soften moose hides before they were smoked as part of the hide-tanning process. Over four years, this scraper was used on ten moose hides and was sharpened regularly.

Betsedea described his wife's use of the scraper this way: "She wrings out the hide with a wooden torque ... and leaves it for a long time. It's left in a knot [to remove excess water]. After it stops dripping she undoes it and does this real hard [scraping it]. She stretches it soft [until it is pliable]. When you use the metal scraper, it really is not very good. This one is very good." (SR)

Jacket

Dene, Chipewyan, Fort Resolution, Northwest Territories

c. 1920 · Deerskin, ermine fur, silk thread

83 × 51 cm · 788/6

Donors: Norah (née Cornwall) and Virgil Pollard

The collection donated to the museum by Norah and Virgil Pollard is a very personal one. This white doeskin jacket, finely embroidered with many silk flowers, is one of a pair of jackets made as gifts for Colonel James Kennedy Cornwall's daughters, Catherine Peace and Norah. James Kennedy Cornwall (1869–1955) was known by several different monikers, including "Peace River Jim." A trapper, trader, mail carrier, army man, businessman and member of the Alberta Legislative Assembly, he worked hard to open the Peace River area for settlement. Cornwall spoke several Dene dialects as well as Cree, and he was present when Treaty 8 was signed at Lesser Slave Lake and Peace River Crossing in 1899. In the 1930s, Cornwall publicly recalled the government's promise to protect the signatories' way of life from white competition and to look after the old and destitute. (SR)

Shirt

Plains, possibly Manitoba

Nineteenth century

Skin, glass beads, porcupine quill, metal

86 × 82 cm · D2.164

Museum purchase (H.R. MacMillan funds)

Across North America, First Nations use porcupine quills for decoration. Once removed from the animal, the quills are dyed and flattened, then wrapped or sewn onto clothing, footwear, baskets, bags and ornaments. This buckskin jacket is decorated with beadwork as well as quillwork. The upper parts of the fringes have been wrapped with quills. The panels are loom work in geometric and meander patterns. Panel work could be transferred from one jacket to another as a person grew or the jacket wore out.

The collector of this jacket, Thomas Wardlaw Taylor, is perhaps best known as one of the Manitoba judges who dismissed Louis Riel's appeal of his treason conviction in 1885. Sixteen Plains First Nations pieces from Taylor's collection came to the museum through his granddaughter Helen Robertson, also the daughter of UBC's first president, Frank Fairchild Wesbrook. (SR)

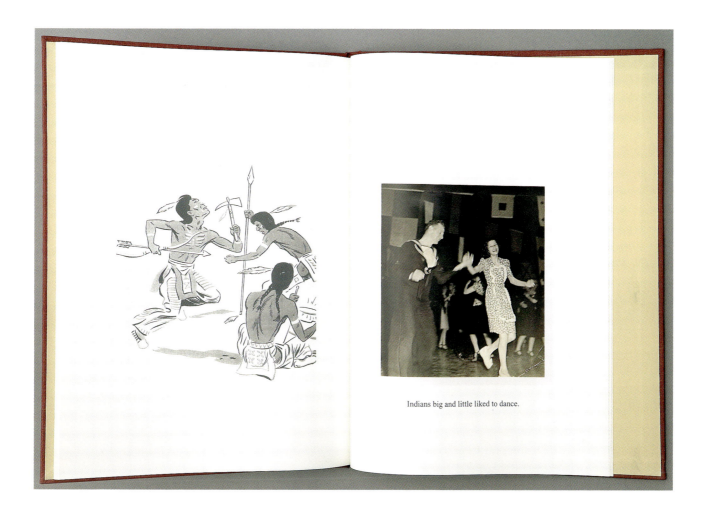

Indians big and little liked to dance.

'Let's Find Out About Indians'

Artist: Alexis Macdonald Seto (b. 1958)
Metis
2001 · Paper, cotton, adhesive, ink, metal
40.3 × 29.8 × 1.5 cm · 2567/1
Museum purchase

In 2002, artist Alexis Macdonald Seto wrote, "I was compelled to do something with the original 1962 *Let's Find Out About Indians* book after finding it at a library book sale. It was exactly the kind of book that I remember finding in my elementary school library when the teacher would assign a report on Indians.

"I flipped through the book reading simplistic statements like … 'The Indians had no alphabet. They used pictures. What does the message say?' The messages conveyed to me were that Indians were (are) uneducated, unsophisticated, crude, simplistic, could only communicate in the most primitive ways, i.e., smoke signals and sign language and of course they were poor, but hey, other than that they were just like you and me … I consider my re-creation of this 1962 book my own personal contribution towards dispelling the negative stereotyping … I plan to continue to use my art to educate, expose and explore issues of cultural identity." (SR)

'Imperfect Doll'

Artist: Jude Norris (b. 1966)
Cree
2003–2007 · Doll (brain-tanned deer hide, cut-glass seed beads, horsehair, ribbon, porcupine quills, brass beads and studs, coloured marker pen); chair (deer hide, sinew, sticks); 18 cm LCD screen; video and audio tape loop
86.4 × 28 × 20.3 cm (installation) · 2699/1
Museum purchase

"This doll is watching a video loop of my hands creating her and writing the words that adorn her dress: 'I am perfect, just as I am,' the Cree translation of that statement (something close to 'I am in a place of beauty, just as I am now'), and 'There is no word for perfect in Cree.' The viewer hears the voices of an elder and a young girl repeat those words.

"For countless generations, similar dolls were used as educational tools. For me, the practice of doll making and use of Cree are evidence of my own cultural education and understanding. The affirmations written on her dress represent both personal and cultural healing, encompassing the process of positive remembering, de-programming, and re-programming."—*Jude Norris*

Dolls

Stoney, Plains
c. 1935–1938 · Fibre
left to right: 8 × 4 × 2.7 cm; 7 × 4 × 1.8 cm;
7.5 × 4.5 × 2.3 cm; 8 × 3.5 × 2.5 cm; 8 × 6 × 2 cm
left to right: 537/2; 537/7; 537/6; 537/5; 537/4
Donor: Jean Telfer

The Morley Residential School was operated by the United Church on the Stoney Reserve in Alberta from the late nineteenth century until the end of World War II. Children from three Stoney bands—Chiniki, Bearspaw and Wesley—attended this school. Jean Telfer, a University of British Columbia graduate, taught there between 1935 and 1938. Roughly a hundred children aged between six and sixteen attended at that time, and Ms. Telfer was responsible for about fifty-five junior girls.

Ms. Telfer recounts in her notes that one day she found a group of her students playing with dolls. Having nothing else to make them from, they had used scraps of paper and fibre, sticking the edges together with saliva. The Telfer collection contains sixty-four items she acquired during her time at both Morley and Port Alberni residential schools. Among them are nine small faceless dolls. (SR)

Moccasins

Nineteenth and twentieth century
Deerskin, moose skin, glass beads,
cloth, silk thread, quill, sinew, dye

Across North America, Aboriginal women have always made footwear for their families. Commonly referred to today as moccasins, this type of shoe varied in form, pattern, material and decorative motif by family and group. This photograph illustrates a few examples from the museum's collection of this remarkable form. The descriptions that follow begin with the moccasin on top.

Created by Gertie Tom (Northern Tutchone, Yukon) in 1994, this moccasin is made from smoked moose hide and is decorated with a beaver ruff and a floral pattern traced in glass beads. Two separate pieces of skin are used in this style of footwear, one for the body and sole of the moccasin and one for the vamp (1638/1 a-b; museum purchase).

This Cree moccasin was collected in Norway House, Manitoba. Here, the entire moccasin, with the exception of the small vamp, is made from one piece of skin. It is decorated with silk embroidery in a floral pattern. (A2.80 a-b; museum purchase, H.R. MacMillan funds).

This Cree moccasin dates to the late nineteenth or early twentieth century. Reuse of materials was a common practice, and the sole of this moccasin was made from a painted parfleche (bison rawhide) bag (1106/2 a-b; donor: Elizabeth Hood).

This skin moccasin is typical of Anishanabe (Ojibwa) moccasins. The vamp and cuff are covered with black fabric and decorated with a beaded floral pattern. Red ribbon or felt is used to form a border (D3.156 a-b).

This Blackfeet moccasin from Montana was made in the early 1900s from skin, glass beads and sinew. The sole, upper and cuff of the moccasin were each made from a separate piece of material. The eagle design was created using glass beads (1060/71 a-b; transfer: British Columbia Provincial Museum).

This early moccasin from eastern North America was sewn from deerskin and decorated with dyed porcupine quills in a simple plant design. Three pieces of material are used for this style of moccasin—one for the sole and upper, one for the vamp and one for the cuff (1060/75 a-b; transfer: British Columbia Provincial Museum). (SR)

Child's dress

Plains

Before 1900 · Deerskin, glass beads,
cowrie shell, sinew, cotton, red ochre

81.3 × 71.1 cm · D2.16

Donor: Florence M. Brodigan

This well-worn, carefully cared for dress was made for a young girl. The tanned deerskin is as thin as a piece of parchment and as soft as rabbit's fur. Originally, the dress was sewn with sinew and decorated with a pattern of red, white, black and blue beads. At some point, a hole in the back of the dress was mended with tiny stitches, making the hole almost invisible. Red ochre, commonly used for spiritual protection, was placed on the dress's shoulders. Later, more decoration was added using cowrie shells and hexagonal beads. (SR)

Acorn cooking basket
Hupa, Northwestern California
Late nineteenth or early twentieth century
Willow, grass
18 cm (diameter) × 13.3 cm · A9246
Museum purchase (and trade with Cargo West)

The design elements on the sides of this cooking basket include a flint mark and a zigzag. The base is decorated with an exploding sun motif.

Standards in practice and in ethics are continuously evolving in museums. In the past, museums commonly engaged in trading with other museums and with dealers. The Museum of Anthropology, looking to broaden its collections, traded objects from the Northwest Coast that it regarded as duplicates. This basket and seven other First Nations objects were exchanged for an argillite plate.

The museum no longer does this kind of trading, recognizing that it means the loss of documentation for objects and the dispersion of collections with their own stories to tell. We recognize also the importance of tangible and intangible cultural heritage to First Nations and honour heritage concerns in our stewardship of this material. (SR)

Trade silver brooches

Europeans manufactured trade silver to be exchanged with First Nations groups for furs. Made in England and France during the eighteenth century, and later in North America, these items were carefully tailored to the interests of the intended trading partners. Popular forms included pendants of beavers, turtles, otters and other animals; bracelets with geometric designs and brooches with cut-out designs of stars and hearts; earrings adorned with eagles; single, double and triple crosses; and gorgets.

Trade silver is eminently desirable as a collectible. Kay and Francis Reif collected the trade silver now at the museum in the 1960s and 1970s. Two pressing concerns made them cease collecting. The first was an ethical and legal issue: archaeological sites, especially burial sites, were being looted to supply demand. The second was a question of authenticity. Trade silver is relatively easy to copy. For all but experts with access to scientific equipment, fakes are notoriously difficult to detect. (SR)

Francis and Kay Reif Collection

top left:
Artist: Charles Arnoldi?
Montreal, Quebec
c. 1760–1820 · Silver
6 cm (diameter) × 0.3 cm · 1590/154

top right:
Artist: Charles Arnoldi?
Montreal, Quebec
c. 1760–1820 · Silver
6 cm (diameter) × 0.5 cm · 1590/156

bottom right:
Quebec?
c. 1760–1820 · Silver
6.2 cm (diameter) × 0.4 cm · 1590/155

bottom left:
Artist: Charles Arnoldi?
Montreal, Quebec
c. 1760–1820 · Silver
6.1 cm (diameter) × 0.5 cm · 1590/167

Wedding basket

Diné (Navajo), Arizona
Before 1911 · Sisal willow, dye
(red bud, black root)
37.5 cm (diameter) × 9.9 cm · D4.67
Mrs. A.J. Beecher Collection

Baskets are most commonly collected by women. The Beecher collection at the museum is a fine example of this phenomenon. While Mrs. Beecher's collection is predominantly focussed on British Columbia, where she lived, it contains excellent examples of baskets from across the continent. Her original label for this basket, which shows signs of use, reads: "Wedding Basket. Made of sisal willow, filled with meal, pollen of larkspur, etc. The bride + groom each take a pinch. The rest is passed to the guests. Opening in the border pattern is to allow the evil spirit to escape. Navajo Indians—Arizona."

Diné (Navajo) women continue to weave baskets in this style for wedding ceremonies. The centre of the basket shown here represents the centre of the earth, from which the people (the Diné) emerged into this world. The inner black band portrays the sacred mountains; the red band represents sunshine, and the outer black band symbolizes rain clouds and darkness. The band around the top represents the dawn, and the break in the pattern is a path showing the way to the light. It is a convention of Diné wedding baskets that the end of the last coil is aligned with this pathway. (SR)

Vessel

Artist: Rachel Nampeyo (1902–1983)

Hopi-Tewa, Polacca, Arizona

c. 1952 · Clay, paint

31.8 × 15.2 cm · D4.14

Museum purchase (field collected)

The late nineteenth-century renewal in Hopi and Pueblo pottery is usually attributed to Nampeyo, an expert Hopi potter from First Mesa, whose husband worked on the archaeological excavation at Sikyatki in 1895. Nampeyo frequently visited the excavations and began to reproduce the fine decorative designs on the pottery unearthed there on her own pots. Rachel Nampeyo, Nampeyo's granddaughter, was similarly highly regarded for her use of traditional motifs. According to Rina Swentzell, writing about Santa Clara Pueblo in the past, "These forms—pots, moccasins, drums—that these traditional people created were known to have breath and were treated as live beings because the essence of life flowed through their parts as well as through the created whole… Pots, baskets, drums and humans were believed to have distinctive qualities and personalities because they were part of, and flowed from, the breath of the cosmos."[1] (AS)

Ollas (water jars)

left to right:

Acoma, Pueblo, New Mexico
Early twentieth century · Clay, paint
32 cm (diameter) × 25 cm · D4.6
The Ruth M. Jones Collection

Zuni, New Mexico
Before 1952 · Clay, paint
17.8 cm (diameter) × 17.6 cm · D4.34
Museum purchase (field collected)

Zia, New Mexico
Mid-twentieth century · Clay, paint
30 cm (diameter) × 27.5 cm · 2633/31
Donor: Doris Shadbolt

Acoma, New Mexico
Before 1944? · Clay, paint
25.4 cm (diameter) × 22.8 cm · D4.41
Donor: W.S. Hill-Tout

In the late nineteenth century, the Pueblos and Hopi peoples in the southwestern United States, heirs to a long history of outstanding pottery production, reinvigorated their traditions to meet new commercial markets. The most commonly produced contemporary pottery types are water jars, bowls and flasks. Designs may be invented, dreamed or copied. Each design has a name and refers to a specific story. Many motifs refer to the weather—clouds, rain, rainbows, snow, lightning, winds and the flowers that bloom after the rains have fallen. Designs may also represent topographical features and ceremonial paraphernalia. Pueblo vessels might be painted with dragonflies, toads, frogs or tadpoles. At Zuni, patterns on bowls used to sprinkle the sacred cornmeal during prayer represented supernatural beings associated with springs and water. In Zia pottery, rainbows are common as are rain birds, which act as messengers to cloud spirits.[2] The *onane,* or road, the line that separates the neck of the jar from the body, is always left incomplete, because traditionally it represented the life of the potter. (AS)

Olla (jar)
Artist: Maria Martinez (c. 1887–1980)
San Ildefonso, New Mexico
Mid-twentieth century · Clay, paint
12.7 × 8.9 cm · D4.25
Museum purchase (field collected)

Workers carrying out excavations in 1908 and 1909 on the Pajarito Plateau discovered a traditional black-on-black pottery style. Edgar Lee Hewitt, the archaeologist in charge of the project, commissioned Maria Martinez, already a fine potter after learning the art from her aunt Nicolasa, to experiment with reproducing this style. Maria and Julian Martinez and their family went on to develop a method for painting designs in dull black paint on the polished surface of black pottery directly before firing.

Two of the most common motifs on these pots are feathers, like that on the jar shown here, which symbolize prayer, and the *avanyu,* a water serpent that represents the Rio Grande River, which traverses sixteen of the nineteen pueblo villages. (AS)

Katsinam (Kachina figures)
Hopi, Arizona
First half of twentieth century
Cottonwood, paint, feathers
left to right:
Palhikmana (butterfly maiden)
Wakaskatsina (cow katsina)?
Qaletaqa (warrior katsina)
Hehey'akatsina (messenger to the rain gods)
left to right: 23 × 11.5 × 4.8 cm; 21.7 × 9.5 × 9 cm;
22.5 × 8.5 × 8.4 cm; 25.2 × 8.5 × 8 cm
left to right: D4.54; D4.57; D4.114; D4.118
Transfer: San Diego Museum of Man (D4.54, D4.57)
Walter C. Koerner Collection (D4.114, D4.118)

The Hopi and many of the Pueblos of
the American Southwest retain a belief
in Katsinam or Kachina, supernatural
spirits that control conditions, beings
and actions in the world of the liv-
ing. The Katsinam and the dead live
in a parallel world, emerging into the
world of the living at set times between
mid-December and mid-July to assist
people to maintain a harmoniously bal-
anced cosmos.[3] Katsinam figures, made
of cottonwood roots, show the princi-
pal characteristic of each of the spirits
taking part in the annual round of

masquerades and dances that reaffirm
the links between living communities
and the spirits. Katsinam masks are
considered sacred, because they embody
the spirit beings themselves, but these
carved figures, seen more as toys, are
given to girls by dancers during the cer-
emonies. (AS)

facing page:
Plaza in Zuni, New Mexico, c. 1890s.
Source: Frederick H. Maude fonds,
MOA Archives

366,

Notes

1. Toba Pato Tucker. *Pueblo Artists: Portraits.* Sante Fe: Museum of New Mexico Press, 1998, pp. 9–10.

2. Ann Marshall. *Rain: Native Expressions from the American Southwest.* Sante Fe: Museum of New Mexico Press, 2000.

3. Terry Wilson. *Hopi: Following the Path of Peace.* San Francisco: Chronicle Books, 1994, p. 13.

3 The Central and South American Collections

The museum's Central and South American collections contain few pieces from the spectacular pre-Columbian civilizations that developed independent of contact with other world cultures. Most of the Museum of Anthropology's collections date instead to the last one hundred years and illustrate the remarkable and inventive syncretic thought of the people of the region. The Mediterranean Sea and the Atlantic Ocean have enabled continental cultures from Africa, the Americas and Europe to mutually influence each other's development and history. Exploration, colonialism, religious crusades, commercial and technological exchange, social experimentation, cultural dialogue and the movement of populations, for good or bad, have followed the ocean currents to create what has been called an Atlantic civilization. This continual contact has created many common cultural and social characteristics across this vast area. Archipelagos like the Azores, the Canary Islands and the Caribbean provided important stopping-off points without which neither Portugal or Spain could have created their western maritime empires. Cultural and religious traits spread from these islands to the American mainland, resulting in a rich heritage that includes vibrant carnival celebrations, religion-inspired dances and cultural fusions that have given rise to new kinds of music, literature, gastronomy and syncretic religions like folk Catholicism, Candomblé and Voudoun, or voodoo. The countermovement brought Europe mathematical, astronomical and geographical knowledge from the Muslim principalities of North Africa, along with architectural innovations, medicinal plants and a

lasting influence on European cuisine from the Americas and Africa. Moreover, through trade, settlement and exploitation, Europe accumulated the capital required to initiate the Industrial Revolution, which irrevocably transformed that continent and the world around it.

The museum's collections from the continents that border the Mediterranean and the Atlantic, though currently small and eclectic, provide a good nucleus for future growth. The most important collections have been assembled by academics and specialists closely connected with the University of British Columbia. Collections include impressive holdings of Mexican masks and mid-twentieth-century Andean folk art donated by UBC professors Alfred Siemens and Blanca and Roberto Muratorio; Guatemalan costumes collected by Dr. Elizabeth Johnson; a comprehensive collection of Quechua clothing and textiles from the Andes collected by Mary Frame and impressive holdings of pre-Columbian textiles from the same area; and excellent ceramics from the American Southwest, including works by Maria Martinez and Rachel Nampeyo, collected by Marianne Dozier. Most of this material, generally referred to as "folk art," was made by subsistence farmers, workers or craft specialists, and it pervades nearly every aspect of Latin American life; it is used to embellish, to clothe, to amuse, to express devotion, to contain food and liquids and to communicate with the invisible spirits and natural forces that must be domesticated on a daily basis. The museum's exhibition of Central and South American, Caribbean and Iberian art and artifacts is the only permanent one in Canada dedicated to this part of the world.

Object descriptions researched and written by Anthony Shelton (AS).

Female figure

Nayarit or Jalisco, México
200 BCE–500 CE · Clay, paint
45 × 27 cm · Ni83
Walter C. Koerner Collection

Despite the absence of major architectural sites, the western Méxican states of Colima, Nayarit and Jalisco witnessed the growth of advanced Mesoamerican civilizations similar to those in central and south México. The region is famous for its hollow, remarkably naturalistic ceramic redware figures, though little is known about them. A few figures have been found in often elaborate shaft tombs, a mortuary structure unique to this region. Most came into museum collections without any accurate provenance. Some experts think the main figure found in such burials may represent a powerful, elite member of the society; other figures may depict retainers sacrificed to accompany that person in the afterlife. The seated female figure shown here holds a rattle, which suggests she was participating in a religious ceremony. Other figures commonly depict warriors, pregnant women, acrobats, male and female couples both seated and standing, and women with children. (AS)

Masks used in the Dance of the Moors and the Christians

The Dance of the Moors and the Christians, along with other dance dramas, were introduced into México by Franciscan missionaries as early as the sixteenth century, as a means of converting indigenous peoples to Christianity. Some of these dances were already popular in parts of Europe. Dances depicting Moors and Christians were performed in Aragón and Burgundy as early as the twelfth century; they spread south to Valencia and Murcia and west to Galicia and Portugal before converging in Castile in the fifteenth century. Many versions of this dance—some of which included dialogue that focussed on the struggle between the Christians, led by Santiago, and the Moors— were adapted to represent the archetypal battle between Spanish Christianity and different "pagan" faiths. In most versions it is the Spanish who eventually win over the native population, whether they be Muslim or the indigenous peoples of the Americas. But in a few versions, such as the Dance of the Plumes, recorded in the valley of Oaxaca in central México, and the Dance of the Tastoanes, in Jalisco, the victors are the indigenous protagonists. With God's help, the indigenous people outwit the Spanish by killing Santiago, who is admonished by God in death for fighting on the side of the sinful Europeans. Santiago requests absolution and is resurrected, after which he leads the indigenous warriors to victory over their tormentors. (AS)

Masks (top row Moors, bottom row Christians)
México
Twentieth century · Wood, paint
clockwise from top left:
23.7 × 18.5 × 2.5 cm; 26 × 16 × 11 cm;
23 × 16 × 12 cm; 43 × 24 × 16 cm;
31 × 23.5 × 12.5 cm; 28 × 24 × 17.5 cm
clockwise from top left:
2655/104; 2655/33; 2655/126; 2655/136;
2655/132; 2655/159
Donor: Alfred H. Siemens

Mask

Cora, Sierra del Nayar, Nayarit, México
Twentieth century
Papier-mâché, paint, hair, fibre
42.8 × 29.4 × 29.1 cm · 2655/3
Donor: Alfred H. Siemens

The Cora, who are among the most isolated indigenous groups in México, were conquered only in the eighteenth century. The Cora religion is a mix of Catholicism and indigenous beliefs with many pre-Hispanic mythical and ritual elements. Nowhere is this more in evidence than during Easter Week celebrations when masks like the one shown here are used to represent the Judeos (Jews).

The youths who play the role of the Judeos fashion their own papier-mâché masks. Under the command of their captains, they begin their hunt for Jesus Christ. After Christ's death, the Judeos take over the village, fighting each other with wooden swords, dancing and threatening anyone who fails to acknowledge their authority. The usual order of the world is reversed; speech is replaced by babble, buffoons taunt onlookers and chaos ensues. With the resurrection of Christ, power reverts to the civil leaders and the Judeos collapse in spasms, eventually washing the paint off their bodies and burning their masks as order is returned to the community. (AS)

Retablo (portable altar)
with figure of Santiago
Artist: Antonio Suplehuiche
Gualaceo, Ecuador
c. 1977 · Wood, glass, paint, metal
40.6 × 23.7 × 13.2 cm · 2721/1
Blanca and Ricardo Muratorio Collection

The intercession of Christ, the Virgin and various saints in everyday affairs is sought by believers throughout Latin America. In some communities, religious images may be ritually bathed and fed, with devotion shown them through dance performances, processions and pilgrimages. In México, Guatemala and the Andean Republics, elaborate masquerades are regularly performed in their honour.

This small shrine is dedicated to Santiago, the warrior saint revered by the Spanish conquerors and later taken up by indigenous people. Santiago's followers thought him a powerful supernatural being and, among other things, associated him with an ability to cure the sick. (AS)

Storage jar

Canelos Quichua, Pastaza Province, Ecuador
Late 1970s or early 1980s · Clay, paint
22 cm (diameter) × 30 cm · 2721/2
Blanca and Ricardo Muratorio Collection

Canelos religious thought, which recognizes a mythical world of ancestors and spirit beings, patterns the future on past transformations. Sungui is the spirit master of the Water World and the first shaman, and Nungwi is the spirit mistress of garden soil and pottery clay. Male shamans receive visions that are interpreted by master potters, who are mostly women.

The Canelos people are best known for their effigy pots and figures. Traditionally these were used for domestic ceremonies, but today they are also made for the tourist market. The effigy pots feature jungle animals, fish people, shamans, spirit masters and imagery that sometimes parody the modern world. The zigzag design on the neck of the jar shown here represents a river, with the lines of dots and small triangles symbolizing the anaconda. Alternating hexagons on the body of the pot represent the iguana, which is flanked by imagery derived from tortoises and turtle shells. (AS)

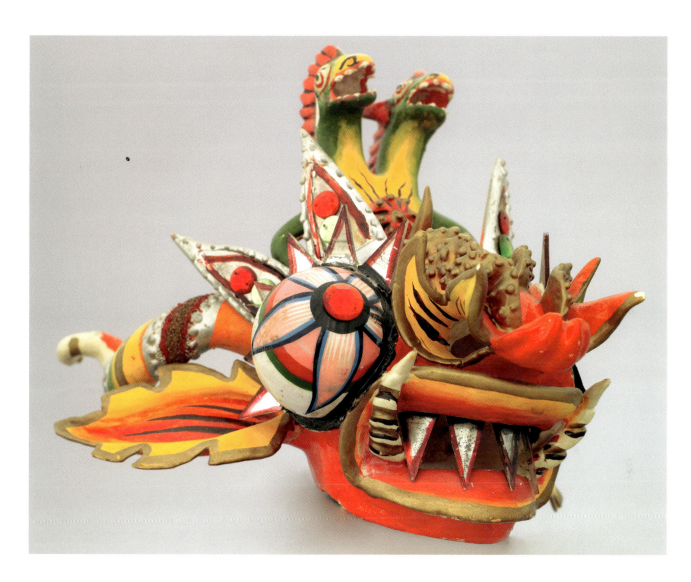

Mask representing the devil

Oruro, Bolivia
Twentieth century
Clay, glass, paint, plaster? wood
32.6 × 25.8 × 18.8 cm · 1362/1 a-d
Donor: Nancy Miller

Masked devil impersonators are common in religious dances across México and the Andes. In México, devil masks can be either the simple horned type, which closely resemble European Christian iconography, or complex, fearsome animalistic masks that developed as a fusion between Christian concepts of the devil and the indigenous belief in *naguals* (spirit helpers). In most contemporary Méxican dance dramas, the devil plays the part of a trickster or buffoon who entertains the audience with sexual jokes, innuendo and scurrilous commentary.

In the Bolivian tin mining town of Oruro, a male and a female devil, Tio (or Supay) and Tia, are believed to control the earth's buried riches, and they are placated and given offerings to ensure the miners' safety and success.[1] During carnival, masked devil dancers invade Oruro until the town's protectress, the Virgin of Socován, banishes them back to their underground home. (AS)

Tunic
Shipibo, Peru
Twentieth century · Cotton fibre and dye
109.2 × 109.9 cm · Se130
Museum purchase

facing page:
Storage jar
Shipibo, Peru
Twentieth century · Clay, caraipe bark ash,
pigment, resin
48 cm (diameter) × 51.5 cm · Se160
Museum purchase

Pre-contact Amerindian pottery, such as the magnificent Marajoara wares excavated from the Lower Amazon, shows great sophistication. The Shipibo and Canelos Quichua people in today's Peruvian and Ecuadoran Amazon are renowned for their intricately decorated jars used to store and ferment manioc beer. Pottery is made by women, and though designs on the pottery are thought to be derived from visions, several women who seem to share nearly identical visionary experiences may decorate a large pot. The coiling techniques used to build a pot are compared to the coiling and uncoiling of snakes, and when used for fermentation the pots are said to hiss like vipers. The designs may look identical to the untrained eye, but each pot's lower body is decorated with an anaconda-derived pattern, while the neck is embellished with a design taken from the constellation of the Southern Cross, both important mythological references for the Shipibo. Similar designs can be found in textiles (see tunic at left) and other media. (AS)

Notes

1. *I Spent My Life in the Mines: The Story of Juan Rojas, Bolivian Tin Miner.* New York: Columbia University Press, 1992.

4 The Circumpolar Collection

Out beyond what's familiar for most of us lie the farthest ends of the earth—places of imagination and fascination. Be it the Northwest Passage or Ultima Thule, the mythic farthest north of the Greek explorer Pytheas, these places have inspired dreamers and explorers. Audiences in Europe and North America at the turn of the twentieth century were spellbound by the race for the north and south poles. Today, a century after Norway and the United States declared the regions conquered by planting flags at the south and north poles respectively, individuals and groups set out every year to try to reach the poles by ever more exotic means.

"Circumpolar" refers to the area that encircles both the south and the north poles. To most people, these regions seem harsh, inhospitable locales, places few choose even to visit. The circumpolar environment is one of the harshest in the world, with bitterly cold winters characterized by periods of twenty-four-hour darkness and short summers with light twenty-four hours a day. To the indigenous peoples of the Far North, however, there is only one word that describes the region—home. Unlike visitors who find the place forbidding, northern indigenous peoples have an intimate knowledge of the land coupled with a respect for the environment.

Museum collections throughout the world contain evidence of our fascination with the North. The Museum of Anthropology's circumpolar collection is focussed, as one might expect, on the Canadian Arctic. The south circumpolar region, made up mostly of Antarctica, was uninhabited until the establishment of scientific

stations during the last century. However, Tierra del Fuego, the southernmost tip of South America, is also considered part of the circumpolar world.

In 1832, three Yamana (Yahgan) were travelling from England to Tierra del Fuego on the same voyage as the young Charles Darwin. Darwin believed the men, despite having been taken to England against their will, had embraced English society during their sojourn and were sad to leave the ship. The next year, however, when the *Beagle* returned to Tierra del Fuego, Darwin was shocked to see that his former shipmates had returned to their previous way of life, one that Darwin viewed as impoverished and "primitive." It probably didn't occur to him that the Yamana had been play-acting in their English clothes, waiting to return to the comforts of home and the known.

Darwin's observations in *The Voyage of the Beagle* about the Yamana were no different from those of many explorers, whalers and missionaries who travelled throughout the circumpolar world. Most of these travellers could not see the world through any lens other than that of their own society. When Darwin eventually wrote about social evolution, he placed the peoples of Tierra del Fuego near the bottom of the evolutionary scale, with Europeans at the apex. His theories provided scientific justification for colonial regimes already acting under the premise that indigenous peoples were in need of "civilizing."

The museum's early northern collections come from explorers, fur traders and government officials. For some of those people, collecting was part of their mandate. For others, collecting and selling items was a source of income. Some simply sought souvenirs, placing specific orders for ivory carvings, miniature kayaks and other items.

The collections at the Museum of Anthropology have many stories to tell. Sometimes these stories are about the people who created the pieces, but more frequently they are about the people who made the collections and their view of the peoples they encountered. In fact, many collections are entirely silent on important aspects of a culture. The museum's Inuinnait (Copper Inuit) ethnographic collection shows a typical bias. Seventy-five per cent of the collection comprises tools, clothing and other items used by men. Items used primarily by women account for the other 25 percent, with children almost entirely absent— one suit of clothing is all that represents them. Collectors of polar items have been, until recently, almost exclusively adult men. The collections they assembled reflected both their interests and the segment of society to which they had access.

We can also see the genesis of Canadian identity based on the idea of "the North" running through the Arctic collections at the museum. Between 1921 and 1924, a team of Danish scientists and anthropologists crossed Canada's North. The Fifth Thule expedition brought back to Denmark stories and legends from the Inuit, as well as thousands of archaeological and ethnographic artifacts. Shortly afterwards, a new permit system for explorers and scientists was implemented so that the federal government would know who was travelling in the Arctic and could ensure that archaeological materials stayed in Canada. Many people shared a sense that Canada was losing an important part of its heritage, among them two friends whose work led to what became the museum's Inuinnait collections. In the 1920s, Mitchell Pierce and Ian Mackinnon were young men working for the Hudson's Bay Company. Of the artifacts they brought south, some went to the Vancouver-based collector Frank Burnett, whose collection would become the foundation for the Museum of Anthropology, and others to the geology department at UBC. As Pierce wrote to M.Y. Williams, director of the university's geology museum, in 1931, "It is almost time that some specimens found their way into Canadian museums."[1]

After World War II, the federal government explored options for economic development among the Inuit. Inuit carvings made from stone became very popular, providing southern Canadians with a tangible representation of the North. The selection of an *inuksuk,* rocks stacked in human form, as the symbol for the 2010 Winter Olympics in Vancouver is part of a continuum that demonstrates how a specific cultural creation can become a symbol of that culture, and finally a national symbol, representing Canadian identity to the world. In situations like this, we need to ask, "Has this transition weakened Inuit culture by appropriating a symbol or strengthened it by bringing an awareness of Inuit culture to a wider audience?" Through the generosity of donors, the Museum of Anthropology has a strong collection representing different forms of Inuit art, from carving, printmaking and drawing to tapestry work and ceramics.

Object descriptions researched and written by Susan Rowley (SR).

Harpoons

Yamana (Yahgan), Tierra del Fuego, Chile
Whale jaw bone
top to bottom: 53 × 3.4 × 1.2 cm;
56.2 × 4.1 × 2.1 cm · 1087/1; 1087/2
Transfer: British Columbia Provincial Museum

Throughout the Americas, many indigenous groups were exterminated following European contact. Most commonly, people succumbed to introduced diseases against which they had no immunity. However, numerous groups also "disappeared" through devious sleight of hand. They were recorded as being extinct, enabling governments to ignore them and colonizers to take over their lands with relative impunity. In some cases, the loss of their language was enough for government to present a people as being extinct. For other groups, it was something as simple as the adoption of European clothing. Frequently, the marker used by government was the death of the last apocryphal "full-blooded Indian," a practice that posited an equivalent between blood quantum and the existence of a culture. Most of these situations applied to the Yamana (Yahgan) people, who even today are often referred to as extinct. However, small communities of people continue to self-identify as Yahgan in both Chile and Argentina. Harpoons like those shown were made for sale to visitors. They are twice the size of the harpoons used in hunting. (SR)

Uqsiq (swivel toggle)
Inuit, eastern Nunavut or Nunavik,
northern Canada
Post 1876 · Walrus tusk, hide
(probably bearded seal or walrus)
11.5 × 4 × 2.5 cm · Na1085
Walter C. and Marianne Koerner Collection

Since the donor purchased this swivel
toggle from a dealer, it unfortunately
has little accompanying documenta-
tion. However, the use of walrus tusk
suggests that the item was made in the
North, and the form of the toggle indi-
cates Inuit manufacture; swivel toggles
are used for quick release on dog team
harnesses. Additionally, this toggle is
decorated with a dot motif common on
Inuit artifacts. Since the incised lines
are in a writing system called syllabics,
which was introduced by missionaries,
the toggle can date no earlier than 1876

and most likely dates to the late nine-
teenth or early twentieth centuries.

The syllabics, a prayer, translate
loosely as "Arnasiapik is writing to Jesus,
please understand and protect from
harm." The word Guuti (God) is written
next to the cross. Perhaps the creator
wished to identify himself with the new
religion? Or perhaps the piece indicates
syncretism, in this case a blending of
Inuit beliefs with Christianity. (SR)

Gutskin parka

Siberian Yup'ik, Gambell,
St. Lawrence Island, Alaska
Before 1956 · Walrus or bearded
seal intestine, cotton, ring seal skin
108 × 46 cm · A2.522
Donor: Francis H. Fay

This gutskin parka was manufactured in Gambell, a small community on St. Lawrence Island, sometime in the 1950s. Gutskin clothing was most commonly made from walrus intestines.

Once the intestines were scraped clean, they were inflated and left to dry. Next, they were split, then scraped until translucent and malleable. Gutskin parkas could be sewn in vertical or horizontal bands, though the latter form was more common. They were originally sewn with sinew, and later with cotton thread using machines.

These parkas were both windproof and waterproof. Just as importantly, they provided spiritual protection. Women wore gutskin parkas while sewing the skin coverings of the large boats and kayaks men used to hunt on the dangerous open waters of the Bering Sea, thus protecting both boats and occupants from female "pollution." Since sea mammals could see contamination and would avoid hunters who were not clean, men also wore gutskin parkas while out hunting. Shamans employed their protective values too, wearing them when travelling between the different layers of the universe. (SR)

Duneraq (Benevolent Spirit) **mask**
Nuniwarmiut, Nunivak Island, Alaska
c. 1920–1940 · Wood, paint, fibre, feather
56.9 × 39.1 × 33 cm · 1570/60 a–s
In memory of Aileen A. Winskill and
Christopher R. Winskill

The Nuniwarmiut believe that all animate beings and inanimate objects have souls. When out on the land, a hunter might glimpse the soul of his prey, revealed as a human face. The frowning face in the centre of this mask indicates a female caribou or reindeer. The hoops represent the layers of the universe, while the feathers are stars.

Nunivak Island's indigenous caribou population became extinct following the introduction of firearms in the late nineteenth century, and in the early 1920s domesticated reindeer were introduced to the island. As this mask shows no evidence of use, it was likely made for the tourist market. Its style and subject indicate a manufacturing date of between 1920 and 1940. After 1936, the eyeholes in masks were eliminated and eyes were painted on instead, possibly to diminish the power of the mask as the population adopted an evangelical form of Christianity.[7] (SR)

Qiigam aygaaxsii (basketry case)
Unangan Aleut, Attu, Aleutian Islands, Alaska
Before 1912 · Most likely *Leymus mollis* (wild rye,
also called American dunegrass), silk fibre
12.7 × 8.9 × 1.2 cm · A2.597 a-b
Donor: Mrs. Sidney Garfield Smith

Unangan Aleut basket makers are known for their exceptionally fine stitch-work. *Leymus mollis* (American dunegrass), is cut, bleached, dried, split into very thin strands and then lightly twisted to use in the weaving of basketry items such as mats, capes, socks, baskets and burial shrouds. Women allowed their thumbnails to grow long to aid in the lengthy process of splitting the grass, and skilled weavers could produce four usable strands from a single blade.

Basketry cases such as the one shown were made during the late nineteenth and early twentieth centuries solely for the export market, and they could take four to six months to complete, with the weaver working several hours a day. Geometric designs were added using a false embroidery technique.[3] The stitch count in parts of this case reaches 270 stitches per square centimetre. This stitch count, in conjunction with the symmetry and the evenness of the strands and stitches in this piece, indicates the extraordinary skill of the unknown artist. (SR)

Drawing

Artist: Keemeloo

Inuit, Apex Hill, Nunavut

1950–1959 · Paper, paint, pencil

91.5 × 66.4 cm · Na1583

Donor: Gordon Yearsley

The tiny settlement of Apex Hill (Niaqunnguut) is located on southern Baffin Island. During World War II, several air bases were constructed in the Canadian Arctic. One of these was an American airbase at Frobisher Bay (now Iqaluit), around which a "shantytown" developed. The federal government founded Apex Hill in 1955 in an attempt to draw Inuit away from the base, building houses, a nursing station, a rehabilitation centre and a school there. In this painting we see a child's impression of the place. Some people were living in snow houses, while others had moved into "southern-style" buildings called 370s or 512s, depending on their square footage. Keemeloo has caught an important moment of transition in the North. (SR)

Woman's outer coat

Inuinnait, Coronation Gulf, Nunavut
c. 1931–1932 · Caribou skin, caribou sinew
117 × 81 cm · A2.516
Donor: Mitchell Pierce

Museum collections of Inuinnait arti-
facts and clothing were made starting
only in the early twentieth century,
when large-scale contact with Europeans
commenced. This "isolated" group
who still used bows and arrows in the
twentieth century intrigued the public.
A small population, the Inuinnait were
able to support museum demand for
their material culture while at the same
time accepting sewing machines and
adopting Western clothing as well as
clothing styles from Inuit groups
to the west.

Caribou-skin parkas, such as the
one shown, cloaked the wearer in the
skins of the animals people hunted
most—an irony not lost on the people.
The hoods of men's parkas bore the ears
of the caribou, emphasizing this connec-
tion. Skins collected in the late summer
and early fall were ideal for clothing,
since the hair had not reached its win-
ter length. Women worked feverishly
to finish all clothing before their family
moved out onto the sea ice, since it was
forbidden to sew skins again until the
sun reappeared above the horizon. (SR)

'Man Devoured by Spirit Monster'

Artist: Eli Sallualu Qinuajua (b. 1937)
Inuit, Nunavik, Puvirnituq
1967 · Serpentine
13 × 10.5 × 8.5 cm · Na1359
Museum purchase (Finning Ltd. and UBC funds)

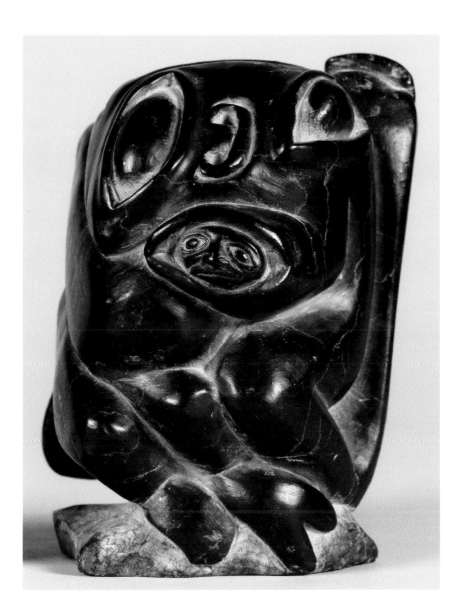

Prior to European contact, creating objects for artistic appreciation alone was unknown among the Inuit. Artistic expression was confined to artifacts of utilitarian or spiritual importance. For example, tools used for hunting were carefully crafted to imbue them with spiritual strength and to demonstrate respect for the spirits of the animals these weapons would kill. Contact with outsiders led the Inuit to create small carvings in ivory, stone and bone as items of trade and gifts. Beginning in the early 1950s, the federal government actively encouraged the development of an art market, and Inuit carvings quickly became the official gift of choice for visiting dignitaries.

Not only was the market saturated by the 1960s, but some people had become concerned that the market had limited the art to particular themes: hunting, life on the land, animals, mother-child relationships. In 1967, a competition held in Puvirnituq (Povungnituk) encouraged artists to create works that were *takusungnaituk* (something that has not been seen). This sculpture by artist Eli Sallualu Qinuajua won first place. It depicts a man being devoured by a spirit monster and represents the world of the unseen. (SR)

Ceramic sculpture

Inuit, Rankin Inlet, Nunavut
c. 1963–1977 · Clay
28.3 × 24.2 × 15.6 cm · 1339/4
Donors: Stuart and Pearl Hodgson

The first commercial mine to operate in the Canadian Arctic was the North Rankin Nickel Mines, which opened in 1957. Both government officials and the mining company knew this high-grade nickel deposit was small, but they hoped exploration would uncover new deposits of nickel or other minerals, providing long-term employment for the Inuit. When the mine closed in 1962, officials looked for ways to maintain the new community, and the Rankin Inlet Ceramics Project was born. The project introduced Inuit artists to clay, and the resulting hand-formed pots, vases and busts, in both glazed and unglazed forms, focussed on themes of traditional life, hunting, animals and, as in the piece shown here, family. Inuit ceramics failed to capture the southern public's interest, however. Prices for these pieces were high, and the perception of clay as a foreign medium for the Inuit may have played a role. Production of ceramic vessels had ceased by 1977. In the early 1990s Inuit artists in Rankin Inlet began creating ceramics again. (SR)

'Musicians'

Artist: Pootoogook Jaw (b. 1959)
Inuit, Nunavut, Kinngait (Cape Dorset)
c. 1990 Serpentine, skin, sinew,
metal, fibre, bone, plastic
38.5 × 37.5 × 11.3 cm · Na1682 a-c
Museum purchase

Known for a short period of time as Cape Dorset, the community of Kinngait was one of the first to produce carvings and prints for the contemporary art market. Today, it has more artists per capita than any other community in Canada.

This multilayered, thought-provoking carving by Pootoogook Jaw illustrates societal change and the feelings it engenders. Singing just as loudly as the guitarist here is the drum dancer, demonstrating the strength of Inuit culture and its ability to adapt new technologies and make them uniquely Inuit. The guitar player, who wears "traditional" Inuit clothing, is ironically juxtaposed with the "traditional" Inuit drum dancer, who sports a suit and tie. At the guitarist's feet stands a large liquor bottle, hinting that all may not be well. The young girl holding the microphone smiles enigmatically at the drum dancer. Is she choosing a path for herself? (SR)

Čiehgahpir (Four Winds hat)
Sami, northern Sweden
c. 1950–1970 · Wool, cotton, reindeer skin,
feathers, dye
29 × 29 × 25 cm · 1128/1
Museum purchase (Ruth Read Bequest funds)

The Sami homelands (Sapmi) cover northern Scandinavia and northeastern Russia. Some Sami are coastal dwellers, living year-round in small communities as fishers. Many are transhumant reindeer herders, moving their herds seasonally between coastal and mountain pastures. Sami clothing, made predominantly of blue felt, is decorated with multi-coloured, geometrically cut pieces of cloth, rickrack and braid in designs specific to families and regional groups that allow people to distinguish relatives and strangers at a distance. This hat from the museum's collection belonged to Per Utsi, who lived in the town of Porjus and was a member of the Karesuando Sami.

A Sami legend tells how the four winds used to blow from all directions at the same time, until a wise man suggested that each take a turn at being the most powerful. Since then, Sami men have worn these "four winds" hats, made from boiled felt and lined with down in winter. (sr)

detail of **Qiigam aygaaxsil**
(basketry case)

A2.597 a-b

Notes

1. UBC Archives. Letter from Mitchell Pierce to M.Y. Williams dated August 29, 1931. M.Y. Williams fonds, Box 21.

2. Molly Lee. "Spirits Into Seabirds: The Role of the Evangelical Covenant Church of Alaska in the Stylistic Transformation of Nunivak Island Yup'ik [Eskimo] Masks." *Museum Anthropology* 24, no. 1 (2000): 5–13.

3. A.T. Shapsnikoff and R.L. Hudson. "Aleut Basketry." *Anthropological Papers of the University of Alaska* 16, no. 2 (August 1974).

5 The European Collection

The collections at the Museum of Anthropology go beyond the collecting parameters of most anthropology museums to include historical and contemporary material from Europe. In the 1877 British Museum publication *A Guide to the Exhibition Rooms of the Departments of Natural History and Antiquities,* we are told that the Ethnographical Room contained "both the antiquities, and the objects in modern use, belonging to all nations not of European race."[1] Since then, the meaning of the word "ethnography," a branch of anthropology, has changed. Today the discipline of anthropology looks at all societies, including European. Clearly, there is no sound reason for an anthropology museum to exclude European material, but historically there has been a preference for doing so.

Early Western museums had Departments of Antiquity, in which objects identified as "Classics" were found in rooms adjacent to objects classified as "Ethnography." The aforementioned British Museum guide tells us that the Antiquities galleries contained "all the smaller remains of whatever nation or period such as Vases, Terracottas, Bronzes, Coins, and Medals, and articles of personal and domestic use. To the latter division is attached the collection of Ethnographical collections." By contrast, the European collections at the Museum of Anthropology can be divided into three broad, sometimes intertwining categories: classics, textiles and ceramics. "Classics" is considered to be the initial field of study in the humanities. It refers to the material culture of the ancient Mediterranean world, specifically Greek and Roman objects made between

1000 BCE and 500 CE. The museum's collection of Egyptian antiquities is also included in the classics category. The majority of the classics collection came from one donor, Charles Sidney Leary, well-known British Columbia lumberman and politician. As a lumberman, Leary took his skills overseas. In Cyprus, where he lived from 1917–1918, he met a collector of antiquities and himself became interested in collecting. Over the next thirty years, Leary built up an extensive collection of Egyptian and Cypriot antiquities. When he exported his collection from Cyprus, he worked closely with the Museum of Antiquities and the High Commissioner there. This was a time when artifacts were being removed from their place of origin with little resistance from local authorities. Leary's principled actions were unusual, and it wasn't until 1970 that UNESCO introduced the Convention on the Means of Prohibiting and Preventing the Illicit Import, Export and Transfer of Ownership of Cultural Property.[2] After Leary's death in 1950, his family donated the collection to the museum. Today, it can be seen in the Multiversity Galleries, where it provides an ideal introduction to the museum's prehistoric, Greek and Roman objects.

Prior to the installation of the Multiversity Galleries, the museum's textile collection was accessible only when needed for a specific study or when included in temporary exhibitions. Audrey Hawthorn, the museum's first curator, had decided that textiles should form an important part of the museum's collection. The lack of adequate storage meant she had to keep these textiles in trunks, hidden from view, but this did not deter her from acquiring examples of diverse techniques, manufacturing methods and materials from cultures around the world, including Europe. Upon her arrival at the museum, Hawthorn had found that the collection contained barkcloths from Oceania and woven textiles from Borneo and Indonesia. As time went on, the museum's collection grew to include examples of cedar bark clothing worn by First Nations, textiles from Okinawa, Japanese robes, mirrored cloth from India and a beautiful Turkmenistan cape. There were some striking examples in these collections, but they were not, Hawthorn wrote, "properly illustrative of such a major human endeavour."

Audrey Hawthorn wanted to build a textile collection that could be used by students, specialists and community groups. She successfully petitioned the Leon and Thea Koerner Foundation, the Fyfe Smith family and others to support the purchase of textile collections from elsewhere as they became available.

Students who travelled to do fieldwork brought back collections from Guatemala, México, Borneo, Nigeria, Sierra Leone and other places, taking care to document the processes they witnessed and even collecting weaving tools and partially completed garments to be used as teaching aids. Members of the local communities in Vancouver also started to donate textiles or bring them to the museum for potential purchase. Some of these garments were European, carried by immigrants from their homelands. Great care had been taken to keep these garments pristine, and the stories associated with them were well recorded. "I remember my mother wearing this [costume while] welcoming liberating armies of Russians *and* Americans at the end of World War II," one donor wrote. Some textiles from Sweden can be found in the museum's circumpolar collection, since they are associated with the Sami people who live in northern Scandinavia and northeastern Russia.

There are about 3,500 objects made from clay at the Museum of Anthropology. These are grouped with the collections of articles from Asia, the Americas and Europe, with objects in the European collection dating from the Classics period (1000 BCE–500 CE) to the present. When Dr. Walter C. Koerner donated his collection of European ceramics in 1988, the museum was able to introduce an important and new focus into the European collections. The Koerner European Ceramics Gallery, designed by Vancouver architect Arthur Erickson, includes 580 ceramics ranging in date of manufacture from the early sixteenth to the early nineteenth centuries. Selected over a period of eighty years, the collection includes unique wares illustrative of the most sophisticated and up-to-the-minute artistry; carefully controlled wares made according to specific sets of rules; and vibrant naïve wares dashed off with a sure hand for the popular market. The main traditions and technologies of the period covered by the Koerner collection are well represented: tin-glazed earthenware, with its pure white surface; stoneware, with its hard, resonant and non-porous body; and lead-glazed earthenware modelled in high relief. The collection demonstrates a range of ceramics not available anywhere else in Canada, and items from it have served as a resource for scholars and inspiration for artists and have been included in museum tours and used in public programming.

More recent acquisitions of ceramics by the museum include works by potters who have migrated to Canada from many places, including Europe. These potters use many of the same techniques and technologies represented in the Koerner

collection, and their pieces serve as contemporary reminders of the technical
virtuosity and innate artistry of the potter throughout history. Some of the most
recent acquisitions have moved the European collection of ceramics into the realm
of humour and devilry. The depictions of religious events found in ceramics in
the Koerner collection, particularly on seventeenth-century tiles, are carefully
modelled. There is no evidence of humour—quite different from the recently
acquired figures of saints and a mock enhancement of the Last Supper, as modelled
by contemporary Portuguese potter Misterio. He has given the figures large noses,
ears and eyes, and he has situated Lucifer as the host for the feast. These products
of a satirical humour may not be as technically proficient as earlier pieces in the
Koerner collection but, like pieces in the collection as a whole, they not only reflect
the genre of their time but also demonstrate the resilience of the ceramic arts.

Object descriptions researched and written by Carol E. Mayer (CM) *and Anthony
Shelton* (AS).

Beadwork blouse

Wallachia, Romania
Second half of nineteenth century
Wool, glass beads, metal sequins
131 × 57 cm · Ce354
Donor: Gabriella Lieblich

This loose-fitting, multicoloured blouse is an excellent example of hand embroidery, beadwork design and the use of faceted metal sequins and metallic thread. The neckband has a diamond-shaped design worked in black, yellow and blue thread, and the sleeves are finished with a single row of faceted gold metal sequins and a fringe made of gold metallic thread and gold metal sequins. Mrs. Gabriella Lieblich, the donor of this blouse, provided the information that it was owned by a princess in the principality of Romania during the second half of the nineteenth century. Mrs. Lieblich purchased it prior to her departure from Bucharest in 1950, as a memento of her homeland. Although the embroidery and the beadwork are similar to traditional designs found on Romanian folk costumes, the extremely rich beadwork and the overall pattern set it apart. (CM)

Stove tile

Austria or Germany
c. 1550–1600 · Clay, lead glaze
41 × 30 × 8.1 cm · Cg113
Walter C. and Marianne Koerner
Ceramics Collection

The Museum of Anthropology has the largest collection of stove tiles in Canada. Dr. Walter C. Koerner collected them as reminders of warmth from his homeland, Czechoslovakia (now the Czech Republic and Slovakia). Stove tiles also served as canvases for interesting imagery, sometimes allegorical in nature. This tile is titled "Das Feuer und Traub," which translates as the fire and grape. The central figure is holding flaming torches and sitting astride a fire-breathing dragon. She could be Carpo, Greek goddess of the harvest, or perhaps Ceres, the Roman goddess of agriculture. To her right a putto (a plump, naked boy) is holding bunches of harvested grapes. In the background are the scales of Libra, the scorpion of Scorpio and the centaur of Sagittarius, representing the months of October, November and December. As well as being the time of the grape harvest, these are also the months of autumn. The vines were usually burned after harvesting. (CM)

Jug
Sobotište? Slovakia
1639 · Tin-glazed earthenware
17.2 cm (diameter) × 18.2 cm · Ch104
Walter C. and Marianne Koerner
Ceramics Collection

This melon-shaped jug was made in 1639 for a man called Hans Fiz. We do not know the name of the potter, but he would have been a member of the Anabaptists, a nonconformist religious sect who produced pottery generally known as Haban ware. The Anabaptist faith, with its demand for utter simplicity in all things, deeply affected the pottery's form and design. Makers' marks were not allowed.

Anabaptists were subject to persecution and sometimes had to flee from their communes. Some headed for the Ukraine, and from there to Canada and the United States, where they worked hard to retain their customs and language. The ceramics they left behind were labelled "folk art" and ignored by the ceramics literature. It is only recently that their place in the history of ceramics has started to be recognized. (CM)

Balsamarium

Roman, Italy
Fourth century · Glass
18.2 × 3 cm · Ce221
Donor: T.W.A. Gray

This elegant double-chambered glass bottle, a balsamarium, was made in Italy and is believed to have been excavated at St. George's Cathedral in Jerusalem in 1927. The body was formed by blowing a glass bubble, pinching it at the centre and then folding it together. It would have contained cosmetics, with the arched handle and side loops used as suspension devices.

Glass was probably brought to Italy by Phoenician traders. The Romans had a penchant for glass, appreciating its ability to be both decorative and practical. The Egyptian craftsmen working near the eastern Mediterranean used casting and cold-cutting to produce a limited range of glassware. Glass blowing was developed in the Syro-Palestinian region during the first century BCE and was most likely brought to Rome after the region was annexed to the Roman world in 64 BCE. This new technology, quick and versatile, revolutionized the glass industry, stimulating fascinating changes in the range of shapes and designs. (CM)

Askos
Cyprus
c. 1050–725 BCE · Clay, paint
22.7 × 12.4 × 6.8 cm · M1.136
The Sid Leary Memorial Collection

The Sid Leary collection contains forty-five objects collected on Cyprus between 1917 and 1918. The island of Cyprus has a long history of international trading and connections with the successive dominant powers in the eastern Mediterranean. Mycenaeans, Anatolians, Minoans and other Mediterranean peoples settled there, adding to the cultural mix. During the first period of the Iron Age, the Cypro-Geometric period (c. 1050–725 BCE), Phoenicians set up a colony at Kition, bringing with them new cultural influences. The pottery from this period is decorated with black and red painted bands of varying thickness, concentric circles and occasional small fillers such as dots or swastikas, all characteristics that inspired the term "geometric." This bird-shaped vessel, known as an *askos*, would have been used as a container for liquids. (CM)

facing page:

Figures of Saint Anthony, John the Baptist, Jesus Christ and Saint Peter

Artist: Joaquim Paiva (b. 1930)

Torres Novas, Lapas, Portugal

2006–2007 · Wood, paint

left to right: 33.8 × 9.7 × 8.5 cm;

32.4 × 12.3 × 10.5 cm; 32.5 × 16.5 × 11.6 cm;

37.6 × 14.6 × 9.6 cm

left to right: 2708/5; 2708/4; 2708/6; 2708/7

Museum purchase

These four religious figures were made by one of Portugal's foremost folk artists, Joaquim Paiva, using simple tools and various types of wood that he finds locally. Paiva was born in Lapas in 1930, and until he was twenty-three he worked as an agricultural labourer. He held various commercial jobs before returning to farm work in 1981; his deteriorating health forced him to abandon that five years later. He taught himself carving techniques beginning then, and his first sculpture of Adam and Eve was followed by other figures inspired by biblical themes. Paiva is also known for his tableaux based on rural and commercial scenes, sports and other themes. At seventy-eight, a widower, he lives alone, committing himself to carving and to the distillation of *aguardente,* a strong local alcohol. (AS)

left:

Artist Joaquim Paiva.

Photographer: Tiago Coen, 2008.

'The Last Supper of Lucifer'
Artist: Manuel Gonçalves Lima (b. c. 1944).
Painted by Virgínia Coelho Esteves (b. 1924)
Barcelos, Minho, Portugal
2007 · Clay, paint
33.3 × 16.3 × 14 cm · 2708/1
Museum purchase

This intricately modelled depiction of the Last Supper, in which Jesus is transposed into Lucifer and the apostles into devils, comes from a member of one of Portugal's most renowned families of ceramic artists. Domingos Gonçalves Lima (Misterio) learned pottery from his grandmother after his mother left home to work in Spain. As a child Domingos made small pottery whistles, as did his grandmother, for sale in the market at Barcelos. After he married Virginia Coelho Esteves in 1944, the toys and figures Domingo modelled were painted by his wife. The couple had twelve sons, two of whom, Francisco and Manuel, continued to work as potters after their father's death in 1995. Domingos's imagery was inspired by the religious faith of his grandmother, and tableaux of devils and saints are common subject matter for both father and sons, who share a satirical turn of mind. (AS)

Tapestry inspired by
French faience ceramics
Artist: Ruth Jones
Canada
1990 · Silk, wool, dye
147 × 110 cm · cf49
Museum purchase

Notes

1. *A Guide to the Exhibition Rooms of the Departments of Natural History and Antiquities.* London: British Museum, 1877.

2. *Convention on the Means of Prohibiting and Preventing the Illicit Import, Export and Transfer of Ownership of Cultural Property.* New York: UNESCO, 1970. http://portal.unesco.org/en/ev.php-URL_ID=13039&URL_DO=DO_TOPIC&URL_SECTION=201.html (accessed April 28, 2009).

6 The African Collection

One of the first donations given to the museum in 1947 during the Hawthorn period was a collection of thirty objects from the Democratic Republic of Congo, then known as Zaire and under the colonial rule of Belgium. The collection was an eclectic one: a few carved figures, a couple of stools, some tools and weapons, some woven baskets and mats, a little clay bowl and an ivory tusk expertly decorated with animals and foliage. The donor, Alfred Bragg, collected these pieces sometime before 1947, brought them to Vancouver and donated them to the museum with no accompanying documentation. The museum received other donations from soldiers, colonial officers, missionaries, teachers, nurses, merchants and anthropologists who had lived in various African countries for periods that ranged from a few months to many years. Some of these objects were better documented, though it wasn't the quality of a collection that compelled the museum to accept it, but the museum's role as a teaching institution. Audrey Hawthorn, as the museum's first modern-day curator, was interested in putting together a collection of objects that could be used to teach museum courses, objects that in her words provided a "good interpretation of [African] material culture."[1] The museum had few resources to build this collection systematically. Audrey Hawthorn did manage occasionally to raise funds to purchase what she was looking for, but the collection remained, as she said, essentially "fragmented and uncoordinated."[2]

Today, there are about 2,800 objects in the African collection at the Museum of Anthropology. That works out to about three objects for every language spoken

in Africa. It is an intriguing and ongoing challenge to envisage how these objects might be organized and displayed in ways that are relevant both to museum visitors—many of whom have never been to Africa and some of whom may be of African descent—and to Africans interested in seeing how they are represented in a museum thousands of miles away.

Prior to 2008, the museum's African objects were displayed in the publicly accessible Visible Storage system, where they were organized according to cultural affiliation and size—small things in drawer units, medium-sized things in medium-sized display cases and larger things in the larger cases. There was some culturally incorrect and awkward juxtapositioning but also an implied unity, simply because everything was displayed together. In many ways, these displays echoed early writing about African arts and cultures by non-Africans, which implied a "oneness," a homogeneity among an essentially static people who existed in an eternally mythic realm. The museum's static display of African objects in Visible Storage, with no context provided, contributed to this kind of interpretation by viewers. None of the museum's tours incorporated the African collection, so visitors were left to their own devices. When African objects were loaned to other museums or removed for exhibitions, their space on the shelf was left empty.

The active involvement of students in the research and mounting of exhibitions at the museum has resulted in two excellent and very different exhibitions that utilized objects in the African collections. The first, the 1991 exhibition "Fragments: Reflections on Collecting," was based on a collection donated by Dr. Eric Sonner. Dr. Sonner's approach to his collection was strictly visual; the objects he purchased fit the tenets of connoisseurship as set out by the art market, and although he became knowledgeable about their cultural context, the pieces he collected also had to "satisfy [his] personal bias and sensibility."[3] The exhibition based on his collection was organized by undergraduate students, under the guidance of Dr. Marjorie Halpin, as a series of fragments, rather like quotations from a book; the objects were presented as being of great individual interest but not as surrogates for an entire culture. The second exhibition, "Wearing Politics, Fashioning Commemoration: Factory-Printed Cloths of Ghana," was mounted in 2001 by MA student Michelle Willard with the guidance of Dr. Elizabeth Johnson. This exhibition was based on the commemorative cloths of Ghana, which are mass-produced for special political, cultural and social events. After completing

fieldwork in Ghana, Willard worked closely with Vancouver's Ghanaian community to construct the themes for the exhibition. Some of the cloth Willard had collected in Ghana was fashioned into a contemporary *kaba* (blouse) and *slit* (skirt) by local Ghanaian Kesseke Yeo. Members of Vancouver's Ghanaian community were involved in the opening for the exhibit, as well as the programming, and the commemorative cloths and clothing became part of the museum's permanent collection. The issues these exhibitions raised, and the similarities and dissimilarities between them, sparked the subsequent reorganization of the African collection.

In the early days, it was useful to think about the objects in the Museum of Anthropology as participants in the worldwide diaspora of millions of people who have moved from their homelands to distant territories, voluntarily or otherwise. When people find themselves in unfamiliar terrain, the desire to retain their identity is strong. However, their desire to live harmoniously with others in this new environment motivates people to develop new ties and contacts, to build new relationships, to grapple with unfamiliar ways of knowing. How might this way of thinking help us better understand the similarly distanced objects in the museum's African collection? Should they be organized by donor? Grouping objects like this would reveal whatever cultural, collecting and colonial contexts are known. Or should a donated object be displayed with other objects from the same geographical area, creating a sort of cultural pluralism? The larger environment of collecting and colonial contexts could be relegated to the virtual world, accessed by computer terminals in the gallery. What should be done with beautiful objects defined as rare by the international art market—should these be integrated into the collection or displayed separately?

These ideas and questions continue to be discussed both within the museum and with the community of people who trace their roots to Africa and now live in British Columbia. For those people, there is also the potential for the creation of new kinds of relationships with the objects in the museum. Objects trigger words, and sometimes stories. Recently, a Liberian student became more and more excited as she described the actions of the tiny thorn figures in the museum's collection. She was surprised by what she remembered once she started talking. For others, too, this triggering of narrative can be a journey of discovery.

Museum collections are not just about communicating or retrieving knowledge but also about evoking the links that unite people to objects in the name of their

shared identity. These new relationships are different from those museums traditionally sought to establish, which focussed on the dynamic between the maker and/or users and the object itself. This approach is about uncovering the past of the objects displayed—detailing their biographies—but it also continually questions what happens in the contemporary time and place of the museum for both viewer and object, whether the viewer's heritage is related to the object or not.

Object descriptions researched and written by Carol E. Mayer (CM).

facing page:

Calabash
Artist: Peter Nzuki (b. 1937)
Masai, Kamba Village, Kenya
Before 1978 · Gourd, fibre, rubber
48.5 cm (diameter) × 48.3 cm · Aj115
Museum purchase

Decorating calabashes by carving on them with awls or knives was once very popular among the Kamba people of Kenya. This art form had gone into decline by the 1920s, and it might have disappeared if not for Kenyan artist Peter Nzuki. Nzuki worked for some years in the National Museum of Kenya, helping to document artifacts, and there he became reacquainted with the traditional material culture of his people. Intrigued by the earlier forms of calabash design, he decided to try to revive the art form, though he was not a trained carver. Like his predecessors, Nzuki blended traditional forms and figures with contemporary events, such as scenes from everyday life and celebrations. In 1974 he gained international recognition when his calabash works were included in the Field Museum of Natural History exhibition "Art in Africa Today." His work can be found in galleries and museums in Kenya and other parts of the world. (CM)

Shetani sculpture

Makonde, Dar-es-Salaam, Tanzania
Before 1980 · Mpingo (ebony wood)
77 cm (diameter) × 85.2 cm · AC110
Donor: Elspeth McConnell

Tanzanian wood sculptures, generally known as Makonde, are dismissed as tourist art by some and accepted by others as valid expressions of contemporary art. Europeans viewed them as exotic souvenirs. For the Makonde people, who had migrated from Mozambique to Tanzania in the 1950s and 1960s, carving became a means to both earn revenue and maintain a cosmological tradition based on the presence of the supernatural within the natural world. The result was a pantheon of well-executed abstract and realistic images by artists who became known in the art world and singled out by collectors. The sculptures have been divided into three main styles: *Shetani* (spirit world), *Ujamaa* (tree of life) and *Binadamu* (everyday life). *Shetani* depict mystical beings who are sometimes mischievous and sometimes malevolent. As shown here, they tend to feature the snake, believed to be a familiar belonging to a witch or a sorcerer, and the bird, who is associated with the sky—one of the locales of the spirit world. (CM)

Ushabti figurine

Egypt
Before 30 BCE? · Faience
18.1 × 4.8 × 4 cm · M3.190
Donor: H.V.S. Page

The museum's Egyptian collection, comprising about 440 objects, consists mainly of beads, small ornaments and figures made of faience. Egyptian faience was made by mixing quartz sand that has been powdered with an alkaline material, such as potash, and natron, a mineral containing sodium. When the mixture was heated to a sufficiently high temperature, a shiny surface formed. If copper was present in the mix, the surface would be a turquoise colour. This Ushabti funerary figurine is modelled to represent a mummy wearing a striped nemes headdress, typically worn by pharaohs. Such figurines were placed in tombs to serve the deceased in the afterlife. (CM)

Pepetu (apron)
Ndebele, Zimbabwe
Mid-twentieth century
Goatskin, glass beads, fibre, wood
33.5 × 30.4 × 1.7 cm · Ab348
Museum purchase

Jacolo (apron)
Ndebele, Zimbabwe
Mid-twentieth century
Goatskin, glass beads, fibre, wood
55 × 45 × 2.5 cm · Ab341
Museum purchase

During the late nineteenth century, the Ndebele people were uprooted from their homeland and relocated to different areas in southern Africa. They clung tenaciously to their culture, and one way they continued to express their identity was through the beaded clothing worn as part of everyday dress. Designs were based both on cultural life in the villages and on the modern world. The two kinds of beaded aprons shown here mark the transitions in women's lives. The designs on the *pepetu,* made by mothers after their daughters undergo initiation rites, reflect the young girl's aspirations towards marriage and home. The airplane is a favourite symbol. The *jacolo* is worn for the marriage ceremony and afterwards on special occasions. Typically it is white and shaped with five panels, which allude to the woman's ability to have children. (CM)

Basket

Angola

Before 1950 · Grass, sisal

34.6 cm (diameter) × 27.5 cm · K4.345

Donor: Anne E. Copithorne

This beautifully balanced coiled basket is an outstanding example of the weaver's technical and artistic skills. The maker's name was not recorded; nor was the village where the basket was made. In time, we may learn what stories it has to tell and whether the designs carry any cultural meaning. The basket's economic value is defined by the art market; its aesthetic value is appreciated by the onlooker or art critic, and its technical virtuosity by those who know how to weave. Perhaps most evocative is the link that unites the basket with people in the name of a shared identity. (CM)

Beaded calabash
Bamoum? Cameroon
Twentieth century
Gourd, glass beads, wood, cotton, shell
18 cm (diameter) × 58 cm · Ae59 a-b
Museum purchase

Beaded calabashes are palm wine
containers intended originally for the
exclusive use of the Bamoum kings
and closely associated with ceremonial
display. Palm wine was an indispens-
able token of hospitality throughout the
Cameroon grasslands. The glass "seed"
beads were nineteenth-century Venetian
and Bohemian trade beads, used as a
medium of exchange. The beads both
symbolized wealth and represented
actual holdings. The calabash was con-
sidered a prestige object and displayed
close to the king. Today, the use of
beaded calabashes has moved beyond
the royal court, and they can be found
throughout Cameroon. (CM)

Thorn carving

Yoruba, Nigeria
Before 1972 · Egun thorn, wood, stain,
rice adhesive, ata thorn
11 × 10.1 × 9.7 cm · Af351
Jessie and Andrew Stewart Collection

Thorn carvings are miniatures depicting scenes from Nigerian life. They were first carved in the 1930s, and they grew to become a popular folk art for the tourist market. The subject matter illustrates the many aspects of rural life, whether religious, commercial, ritual or domestic. The carving is done by men, using different-sized thorns from the *ata, egun* and *shagamu* trees. The carving shown here probably represents a Muslim ceremony. The figures are composed from thorns of differing hues, each carved separately before the pieces are glued together. This carving was purchased from the artist, and it bears the stamp of his individual style. Even though carvings such as this were made for tourists, for Africans living in the diaspora they can trigger memories and stories about home and identity. (CM)

Agbogho Mmwo

(Maiden Spirit) **mask**

Igbo, Nigeria
Mid-twentieth century
Wood, pigment, cotton fibre
37 × 35 × 17 cm · Af337
Donors: Alan and Erika Sawyer

The *Agbogho Mmwo,* or Maiden Spirit, mask is one of the most important mask types among the Igbo people of Nigeria. The spiritual and moral qualities of young women are idealized through exaggerated small features and a complexion that is as white as chalk, a substance used to ritually mark the body in both West Africa and the African diaspora. *Agbogho Mmwo* are danced by men at festivals during the dry season to promote abundant harvest and at funerals of prominent members of society to escort the dead to the spirit world. The dancers mime the graceful movements and deportment of young women and sing in praise of both real and spirit maidens. (CM)

facing page:
Emmanuel Onwazolum performing the *Agbogho Mmwo* (Maiden Spirit) dance at the Museum of Anthropology, 1977. Photo: Bill McLennan

Jar

Artist: Ladi Kwali (c. 1925–1984; attributed)
Yoruba, Nigeria
c. 1972 · Clay, pigment, glaze
30.5 × 18.7 cm · Af442
Jessie and Andrew Stewart Collection

The Nigerian potter Ladi Kwali was already creating beautiful pots in the 1950s when well-known English potter Michael Cardew was recruited by the government there to build a pottery training centre in Abuja. This was a rather odd venture, because Nigerian potters had a long history of making magnificent pots that served the needs of the community. However, Cardew's job was to help create a rural industry that would replace the factory-made tableware being imported for European-style meals. He introduced the wheel, along with the use of glazes and high-firing kilns, and persuaded Ladi Kwali to come to Abuja. She learned to throw, producing some tableware and smaller pots, but she continued to hand-build pots which she then glazed and high-fired, creating a sort of Anglo-Nigerian style. This jar has been glazed with iron oxide, cobalt and chrome oxide imported from England. Ladi Kwali's pots were sought after by collectors, and the Abuja pottery was renamed in her honour. Nigerian pottery continues to command high prices today. (CM)

Kente cloth

Asante, Nkwataya, Ghana
Mid-twentieth century · Cotton, dye
610 × 447 cm · K2.152
Museum purchase (Walter C. Koerner funds)

Kente cloth is made by the male Asante weavers of Ghana. It is the best-known of all African textiles and is easily identified by its vibrant patterns of bright colours and bold geometric patterns. More than three hundred of these patterns have been identified and each contains layers of meaning derived from proverbs, historical events, authority figures and plants. By wrapping themselves in the kente, the wearers not only cover themselves but also extend a form of symbolic communication understood by others wearing the cloth. The kente cloth shown here has a gold dust pattern, a symbol of wealth, honourable achievement, royalty and spiritual purity. Originally worn only by kings, and even then only during extremely important events, kente is now widespread and is viewed by the African diaspora as an icon of African cultural heritage wherever it is worn. (CM)

Akuaba figures

Fanti, Ghana
Twentieth century
Wood, glass beads
45.6 × 8 × 4.8 cm · Af589
Eric Sonner Collection of African Art

Akuaba figures, usually with disc-shaped heads, are prolific throughout Ghana. The figures in this pair have the long rectangular heads specific to figures made by the Fanti people. They are characterized by high foreheads and small facial features set low on the face, all signs of great beauty. The carved rings around their necks represent rolls of fat—a sign of health, beauty and prosperity. The name *Akuaba* comes from a legend about a woman called Akua who was barren but wanted to become pregnant. She was advised to commission the carving of a small child and carry it with her at all times, treating it as though it were real. The woman was mocked by her neighbours, but she eventually became pregnant and gave birth to a girl. Soon other women followed suit, and the Akuaba became one of the most recognizable forms in African art. All Akuaba are female, partly because Akua's child was female and also because the Fanti are matrilineal. (CM)

Heddle pulley

Senufo, Ivory Coast
Twentieth century
Wood · 23 × 10.2 × 6.5 cm
Ag67 a-b
Eric Sonner Collection of African Art

Heddle pulleys such as this are created
purely for the owner's aesthetic satis-
faction. They are used in strip-weaving,
a process that uses very small looms
to produce long, narrow strips of cloth.
These strips are sewn together to cre-
ate a larger textile, such as a blanket or
a piece of clothing. The small looms are
highly portable and easy to assemble.
Heddle pulleys, positioned above the
loom, help ease the movement of the
warp threads. Carved by master carvers
or by the weavers themselves, they are
often decorated with animal figures,
such as gazelles or hornbills, and
more rarely with human figures. The
meanings of these figures are personal,
created by each weaver. Some figures
are reminders of particular events and
are kept by families to pass the infor-
mation on to the next generation; some
evoke the characteristics of the animal
portrayed; some offer protection. (CM)

Tyi Wara (or Chi Wara) headdresses

Bambara, Mali
Twentieth century · Wood, stain
right: 103 × 31 × 15 cm · K2.233
Museum purchase (Walter C. Koerner funds)
facing page: 73 × 16 × 5.5 cm · Ag66
Eric Sonner Collection of African Art

These two headdresses, one male and one female, were made to be danced as a pair at harvest festivals to honour Tyi Wara, a half human and half antelope mythical being who taught agriculture to the ancestors of the Bambara people of Mali. Together, these headdresses embody the ingredients necessary for successful cultivation, their long horns representing the tall growth of millet. The penis on the male mask signifies the rooting of the grain, and the baby on the back of the female represents all humankind. During the early twentieth century, these intriguing forms became icons of what Europeans termed "primitive art." They inspired artists such as Pablo Picasso and Henri Matisse and today are among the most recognizable and collectible forms of African art. (CM)

facing page:

Sowie mask

Mende, Sierra Leone

Twentieth century · Wood, stain, sisal

40.3 × 22.5 × 18 cm · K2.234

Museum purchase

(Leon and Thea Koerner Foundation funds)

This type of mask is made by men but worn only by females who dance for the Sande women's society. Initiation and socialization of young girls takes place in Sande camps. There they are prepared for marriage, trained in both domestic and economic pursuits and in singing and dancing. The Sande maskers visit the camps to remind the girls of the ideals of female beauty and virtue. The elaborately braided hair relates to cosmetic skills and to sexuality; the creases in the neck denote good health; the smooth skin and broad forehead symbolize youthfulness, intelligence and nobility; and the composed expression reflects an inner serenity. The bird figure perched on top of the head has many meanings: clairvoyance, love, fertility, power, danger, discipline, prudence and laughter. The mask's shining blackness connotes the essence of female beauty and moral purity. When the girls leave the camp, they are considered to be women ready for marriage. (CM)

Notes

1. Audrey Hawthorn. *Labour of Love: The Making of the Museum of Anthropology, UBC. The First Three Decades, 1947– 1976.* Museum Note 33:50. Vancouver: UBC Museum of Anthropology, 1993.

2. Ibid.

3. Personal correspondence between Eric Sonner and Marjorie Halpin, March 24, 1990.

7 The Asian Collection

"You are quite right, we need some Far East culture material, especially since the interest and operations in that general field are increasing all the time. And to get a good cultural range is very important, and a rare chance for us."[1] Audrey Hawthorn, the Museum of Anthropology's first curator, wrote these words in a letter to Wayne Suttles, a UBC professor who had offered to do collecting for the museum while he was in Okinawa in 1954. Suttles knew Japanese well, and he had done translation work in Japan during World War II. The Okinawan collection he developed served as the foundation for the museum's Asian collection, which spans the breadth of Asia. In 1960 the museum purchased a significant collection of more than two hundred and fifty Japanese village crafts from well-known Japan specialist Ronald Dore, then a professor of Asian Studies at UBC. The museum's Japanese holdings have continued to grow through generous donations and additional field collections.

Southeast Asia was already represented at the museum by a significant group of objects, part of the major Pacific collection donated to UBC in 1927 by Frank Burnett. Audrey Hawthorn was ahead of her time in expanding the museum's collections to include East Asia, since most anthropology museums considered that area to be outside their mandate. The university was building Asian studies in various disciplines at the time. Mrs. Hawthorn encouraged faculty members and their students to do field collecting. Among the Hawthorns' UBC friends was the well-known historian Ping-ti Ho, who found important antiquities for

sale in Vancouver's Chinatown, objects brought from China by people fleeing the revolution there. Mrs. Hawthorn was easily persuaded to purchase them and thereby build the museum's collection in the area of Chinese fine art, including paintings and calligraphy. Through the research of another UBC China specialist, Graham Johnson, she learned that the Vancouver-based Jin Wah Sing Musical Association was about to dispose of a group of rare Cantonese opera costumes dating from the first half of the twentieth century. With the support of a number of Chinatown organizations and individuals, Mrs. Hawthorn was able to purchase these costumes from Jin Wah Sing, which in 1991 donated many more. The museum's Chinese collection includes many other donations and purchases, highlights of which include the more than two thousand coins and amulets collected by Dr. Hugh Campbell-Brown and the Victor Shaw Collection of Chinese Arts, which comprises ceramics and objects made of gold and bronze spanning Chinese history.

Michael Ames, the museum's second director, was an anthropologist whose research was based in South Asia. Ames supported the broad development of the collections, but one of his doctoral students, Stephen Inglis, now director general of research at the Canadian Museum of Civilization, developed carefully documented field collections from India relating to his interest in popular culture and religion. Inglis's doctoral research focussed on a caste of potters in Tamil Nadu, and from them he obtained a number of ceramic votive figures. Inglis also collected materials from folk performers whose art was being undermined by the growing appeal of cinema. In addition, his collection of several hundred calendar prints offers rich material for the study of the iconography of popular religion, among other themes. These prints are complemented by Victor Hardy's significant donation of images of deities in bronze and brass, many showing wear from use by worshippers. Highlights of the South Asian textile collection include beautifully embroidered *phulkaris* from Punjab, block-printed cloths from Pakistan, many examples of mirror work and two *patola* cloths, intricately patterned saris of diaphanous silk.

The museum's Korean collection was developed through donations from Canadians who had worked there in the early- to mid-twentieth century, as well as through gifts from the government of Korea and from local Korean-Canadians. Its strengths are clothing, along with related accessories, and masks used in folk performances. The Southeast Asian collection was also enhanced by a

significant gift from two Canadians of Asian origin, Miguel and Julia Tecson, the strength of which is ceramics collected while the Tecsons lived in the Philippines. Some of the ceramics are indigenous, but many were exported to the Philippines from China and Southeast Asia over the course of nearly a thousand years. They were treasured in the Philippines because of the brilliance of their glazes. Many became family heirlooms, handed down from generation to generation.

The Asian collections of the Museum of Anthropology have benefited from the generosity of many people. These include not only the scholars and students who have used their expertise to build the collections, but also the benefactors, many of whom had lived in Asia. Some collectors donated their objects, while other collections were purchased. Generous financial donations have made such purchases possible, including funds from Dr. Walter C. Koerner and the Leon and Thea Koerner Foundation; funds generated by the Museum of Anthropology's shop, which was run by volunteers until 1998; the Ruth Reid bequest for the purchase of textiles, and a very generous bequest from Florence Fyfe-Smith. The government of Canada offers special tax credits for donations and purchases that are demonstrated to be "of outstanding significance and national importance." A number of acquisitions in the Asian collections have earned this designation, including the rare and precious robes and other regalia used by heads of the Tashi Dhundup-Yapshi Yuthok family, one of the highest-level aristocratic families in Tibet.

Object descriptions researched and written by Elizabeth Lominska Johnson (ELJ)*, Jasleen Kandhari* (JKa) *and Carol E. Mayer* (CM)*.*

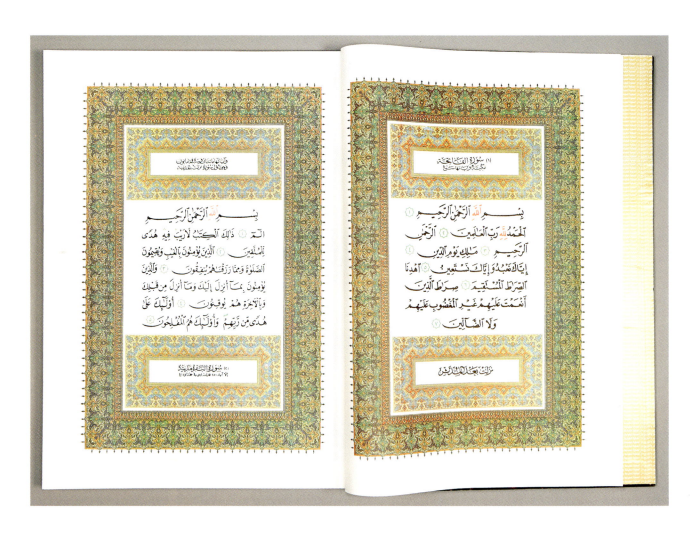

Qur'an

Arabic, Middle East

1994 · Paper, ink

64 × 48 cm · MOA library collection

Donor: Farouk Elesseily

Calligraphy is an artistic signature of Islamic art; it is also a transmitter of knowledge about Islam and about Muslim culture. Some of the finest calligraphy can be found in the Qur'an, the holy book of Islam. This Qur'an was presented to the Museum of Anthropology in 2001, at the time of the opening of the exhibition "The Spirit of Islam: Experiencing Islam through Calligraphy." The exhibit marked the culmination of a two-year collaboration between members of the Muslim communities in the Lower Mainland of British Columbia and the staff of the museum. The words in this Qur'an are the same as those revealed to Muhammad (*Peace Be upon Him*) by God (Allah) through the Angel Gabriel in 610 CE. These words, and the knowledge they conveyed, were addressed to all humanity and were shared orally until the time came for them to be written down. Since that time, the text of the Qur'an has never been altered. (CM)

Munisak (ikat robe)

Uzbekistan, Central Asia

Twentieth century · Silk, dye

170.5 × 130 cm · 915/2

Museum purchase

Boldly patterned woven silk ikat robes reached the zenith of their production in Central Asia in the nineteenth century. This elaborate *munisak,* or woman's unlined, long-sleeved robe, has a fitted bodice attached at the waist to a pleated skirt. The tie-dyeing technique used in ikat production lends a colourful vibrancy to the robe, with its bold saturated colours. Its pinkish colour is created by the red weft. This robe was collected in Kabul, Afghanistan, in the early 1960s. The traditional pomegranate and floral motifs suspended from ram's horns symbolize resilience and abundance.

Ikat robes served a social function, being used either as domestic hangings or as elaborate personal costumes. This *munisak,* part of the bridal dowry, would have been layered over other garments and adorned with necklaces and ornaments, displaying the wearer's wealth and status in society. (JKa)

Chyrpy (mantle)

Tekke Turkmen, Turkmenistan, Central Asia
Twentieth century · Silk, silk thread
124 × 80 cm · M4.50
Museum purchase (Leon and Thea Koerner
Foundation funds)

This vibrant Tekke tribeswoman's mantle, called a *chyrpy,* is richly embroidered in maroon and green, with floral sprays of the tulip symbolizing abundance and fertility. Its bright yellow colour indicates that this garment would have been worn by a middle-aged married woman. The Turkmen have effectively preserved their tradition of chain stitch embroidery, with this type of garment being the most striking example. The *chyrpy* is worn like a shawl, draped over the woman's tall coif of hair. The vestigial sleeves, left hanging, form embroidered bands at the back of the mantle in a manner similar to that of the Hungarian *szur,* an archaic mantle of Eurasian origin. (JKa)

Malir (wedding shawl)

Meghwar, Tharparkar district, Sindh, Pakistan

Twentieth century

Cotton, silk, glass beads, silver alloy, shell

203 × 138 cm · 1472/3

Museum purchase

The folk embroideries of the Sindh people of southern Pakistan are among the richest in South Asia, with striking textiles produced in the desert region of Tharparkar. This spectacular red and black *malir,* or wedding shawl, is mordant-dyed, resist-block printed and embroidered in the *pakkoh* style, in silk with mirror work and beaded tassels. It would have been produced by a Meghwar bride and her family and presented as a gift to the groom as part of his wedding-day attire. It would be draped around the bridal couple towards the end of the ceremony. The stylized peacocks embroidered in desert floral motifs at the four corners of the shawl symbolize prosperity and fertility for the newly-weds. The colour red, which symbolizes blood and therefore life, is always worn at marriage ceremonies in South Asia. (JKa)

Dress

This everyday-wear dress was worn by a woman of the Kuchi, a nomadic tribe who are part of the Pashtun ethnic group. It was probably constructed from a variety of elements from various sites, some acquired through trading. The skirt's back is pieced from panels of machine-printed cotton textile, probably from Russia. The discs that embellish the dress, emblems of good fortune, are referred to as "solar discs," "dress flowers" or *gul-i-peron*. The triangular amulet safeguards the wearer, and its beaded fringe is said to entangle the evil spirits, keeping them away from the body. A densely embroidered panel of floral forms and tree of life motifs that symbolize fertility decorate the bodice front. Embroidery around the edges and openings of the garment protect the wearer from harmful forces. (CM)

Pashtun, Kuchi, Afghanistan
Twentieth century
Cotton, silk, rayon, metal, shell, glass, plastic
160 × 122 cm · 1201/1
Museum purchase
(Ruth Read Bequest funds)

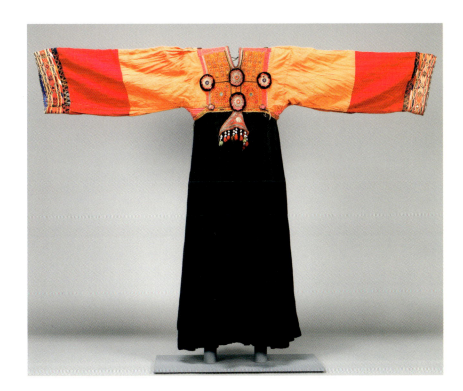

Yantras (Hindu tantric paintings)
Artist: Pandit Sri Varohi Jha
Harinagar Village, Bihar, North India
Twentieth century · Paper, gouache
20 × 20 cm · *Clockwise from top left:*
Ef168; Ef167; Ef170; Ef169
Museum purchase

Yantras are geometric paintings, forms
of symbolic art with high spiritual con-
tent. Essentially, these Hindu tantric
paintings are tools for contemplation
and visualization practices, serving as
substitutes for anthropomorphic images
of Hindu deities. The *tantrika* or *sadhaka,*
the practitioner, performs *sadhana,*
or worship, that consists of repeated
rituals and meditations using tantric
texts, ritual chants (mantras) and yantra
paintings. Illustrated here in a clock-
wise fashion, from top left to right, are
the yantras *Sri Bhairavi, Dhumavati,
Vashi Karan* and *Sri Kartavira* from the
Kali *mandir,* or temple, in Harinagar,
Bihar. (JKa)

Pankha (fan)
Gujarat, India
Twentieth century
Rattan, bamboo, fibre, glass beads
30.5 × 24 × 2.4 cm · 758/3
Museum purchase

The *pankha,* or hand fan, has been pro-
duced in a variety of shapes and sizes,
using different techniques and materi-
als, in accordance with its particular
function, be it practical or ceremonial.
Simple fans made of palm leaf are used
to whisk away flies or to fan the bar-
becue. A more complex fan might be
used for temple ceremonies or social
gatherings or carried by a bride on her
wedding day. This finely beaded fan was
handcrafted by a woman who would
have worked at home. On one side, she
has created a traditional stylized floral
pattern using coloured beads. The other
side is covered with pink fabric, sug-
gesting that this fan was intended to be
decorative rather than functional. This
craft is guaranteed a future: the heat of
the day always creates the need for a
good fan. (CM)

Betel cutter

Madhya Pradesh, Central India
Nineteenth century · Bronze
12 × 5.5 × 1.7 cm · Ef314
Donor: Victor Hardy

This bronze betel cutter produced in central India depicts an elaborately adorned, bejewelled amorous couple, or *mithuna*. The male's legs form the cutter's handles, and there is a blade on the right side of his body. The female offers him betel in her upturned palm, lending an erotic charm to this simple utensil.

Betel cutters form part of the array of utensils and utilitarian objects used in the *tambool* chewing custom. The nut-cutters crack the areca nut to release the fruit, which is then wrapped in a betel leaf. Betel, *paan* or *tambool* chewing is a social custom prevalent throughout India. Traditionally, this custom represented the deity in religious ritual, was the symbol of auspicious beginnings, acted as the seal on alliances and even served as inspiration for verse, legends and paintings. (JKa)

Double ikat patola sari

Gujarat, India
Twentieth century · Silk
484 × 104 cm · 764/1
Museum purchase

This sari was collected in Sumatra, Indonesia. Historically, Indonesia has selectively absorbed elements of Indian culture, transforming them into uniquely Indonesian forms. *Patola*s from India were traded for sandalwood and spices in the sixteenth and seventeenth centuries.

This *patola*'s warp and weft were tie-dyed separately before weaving, creating a subtle yet rich pattern with a repeated eight-rayed floral motif known in Indonesia as *jelamprang*. The design was emulated in Java, where it was reserved by the sultan of Surakarta for his family's exclusive use. Because of the elaborate weaving technique used to make them, *patola*s were expensive textiles, held in high esteem both in Indonesia and in India, featuring prominently in social and religious ceremonies and becoming symbols of wealth and family lineage. (JKa)

Ravi Varma.

'Lord Vishnu'

Lithographed paintings are forms of popular art mass-produced throughout India and used in everyday life in a variety of ways, including on greeting cards, in children's schoolbooks and, most commonly, as decoration on calendars issued by businesses for marketing purposes, and then framed for decoration and devotion.

This calendar fragment shows the work of artist Raja Ravi Varma, who established India's first lithographic press in 1891. Illustrated is Varma's rendition of the Hindu god Lord Vishnu, flanked by his consorts, Sridevi and Bhudevi, rendered in the neo-classical style introduced by Ravi Varma through his mastery of Indian and Western styles of painting. Although painted in the 1890s, this reproduction was printed in the 1940s and used in a calendar distributed by A. & F. Harvey Madura Mills Company. (JKa)

Artist: Raja Ravi Varma (1848–1906)
Kerala, South India
c. 1940 · Lithographed print
49 × 34.9 cm · Eg236
Donor: Stephen Inglis

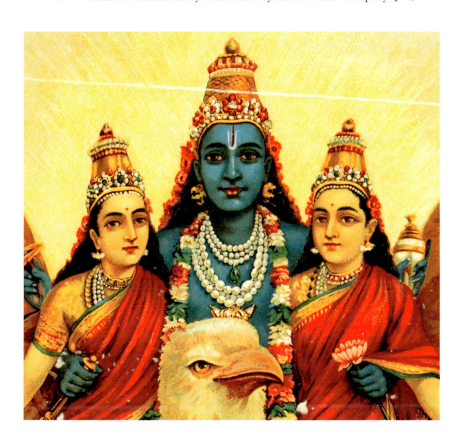

Votive offering

Artist: K. Muthusamy Velar
Arappalayam Village, Tamil Nadu, India
1975 · Clay, paint
59.5 × 54 × 20 cm · Eg15
Museum purchase

Modelled clay figures of bulls, elephants and horses are made by members of the Velar (potter) caste to be used as personal votive offerings during village festivals. The figures, which can be larger than life-sized, are often made in groups of five or six. They are painted with the appropriate regalia and set up in front of or inside the village temple, in readiness for the village gods to ride on their nightly protective rounds. These revered animals are considered suitable mounts for the gods through their association with the great heroes and gods of popular history and mythology. Although the horse is not indigenous or even common in south India, it is the most common mount of the village gods. (CM)

'Shiva Nataraja'

(Lord of the Dance)
South India
Eighteenth century · Bronze
31.5 × 27 × 9.3 cm · Eg95
Donor: Victor Hardy

Shiva Nataraja shows the Hindu god Shiva as a graceful, four-armed dancer amid a ring of flames with his unkempt hair flying out around his head. *Shiva Nataraja* acts out the end of one life cycle while welcoming in the next. As Shiva dances, he tramples the dwarf demon, Apasmara. He drums with his upper right hand while in his upper left he holds a flame. He makes the *abhayamudra,* have no fear, with his lower right hand, and points towards his left foot with the hand gesture symbolizing release.

This image of Shiva illustrates the five cosmic activities of a god—creation from the drum's sound, protection from the gestures of the raised hands, destruction from the ring of flames and fire, salvation from the raised foot and refuge to the human soul from the foot trampling the dwarf-demon figure. (JKa)

'Maha-kola-sanni-yakka' mask

Sri Lanka
Twentieth century · Wood, paint
47.5 × 35.5 × 11 cm · Eh26
Museum purchase

The *Sanni Yakuma* healing and exorcism ritual practised in Sri Lanka is intended to combat diseases and afflictions caused by the Sanni group of demons. It includes a number of masked dance-drama performances, which include eighteen or more apparitions of the chief demon, Maha-kola-sanni. The officiating healer honours Buddha, then appeases the demons with offerings, dancing and chanting. In this mask, *Maha-kola-sanni-yakka,* eighteen Sanni demons can be identified by specific visual clues. The demon Kanna Sanni, for example, has one closed eye, representing the blind; Gonna Sanni's open mouth represents the mute, and Kora Sanni, with its badly twisted face, indicates severe stroke. There is a full set of these masks in the Museum of Anthropology collection. This one was designed not to be worn but to be hung from a tree or on a wall during the ritual. (JKa)

Tiffin box

Burma
Twentieth century · Bamboo, lacquer
49.7 × 22.5 cm · 804/4 a-f
Museum purchase (Barrett Montford
Endowment funds)

Tiffin boxes are associated with the
idea of taking a light lunch, a custom
introduced into India by the British
during the nineteenth century. Today,
tiffin boxes can be found in many parts
of Asia, and though they continue to
be used primarily as food carriers, they
have also become an important art form.
This four-tiered tiffin box is adorned
in the unique style of incised lacquer-
ware decoration known as *yun,* one of
the major artistic traditions in Burma.
Palace scenes from the Mandalay Court,
nandwin, are repetitively depicted
against a red-orange background in a
rhythmically lively manner. The boxes
are separated by the parallel, concentric
lines characteristic of Burmese *yun* bor-
der decoration. (JKa)

Lidded boxes

Sawankhalok, Thailand

c. 1350–1600 · Stoneware, glaze

left: 9.7 cm (diameter) × 7.2 cm · 1262/158 a-b
Miguel and Julia Tecson Collection

middle and right: 5 cm (diameter) × 4.5 cm;
22 cm (diameter) × 11 cm
2686/4 a-b; 2686/5 a-b
Donors: Lt. Col. Thomas Moore and
Mrs. Kathleen V. Moore

Thousands of these small stoneware boxes were made at the ceramic centre of Sawankhalok, north of the city of Sukhothai, Thailand. This centre flourished for about two hundred years, and the ceramics produced there were part of a thriving export trade to Indonesia, the Philippines and the Middle East. It is thought that the original kilns were set up by Chinese potters, who started the production of a vast repertoire of containers of many shapes and sizes, religious and mythical figures, and architectural products such as tiles and water pipes. The decorations on these wares were as diverse as their functions. The boxes shown here travelled to the Philippines in the fourteenth or fifteenth century, where they remained until they were brought to Vancouver during the twentieth century. Their iron underglaze decorations include floral motifs, netting, lotus buds and concentric bands. (CM)

Kenyalang (hornbill carving)

Iban, Sarawak, Malaysia

c. 1920 · Pelai (alstonia wood), paint

53.5 × 41 × 11.2 cm · B122

The Burnett Collection

Frank Burnett collected this carving of a *kenyalang*—a rhinoceros hornbill—in the early 1920s during his travels through Sarawak, one of two Malaysian states on the island of Borneo. This bird was of great cultural importance to the Iban people; once associated with headhunting raids, it was later incorporated into the *Gwai Kenyalang,* a festival held at the end of the rice harvest. The *kenyalang* is publicly displayed during the festival and people make offerings to it in the hopes of securing a bountiful harvest.

Today, the elaborate, distinctively carved *kenyalang* continues to be associated with the Iban rice harvest. The bird is the main image on Sarawak's coat of arms, and decorative carvings of it are sold to collectors and travellers. (CM)

Wayang kulit (shadow puppet)

Balai Agung, Surakarta, Java, Indonesia

Twentieth century · Water buffalo skin, bone,
fibre, gold, paint

68.4 × 25.2 × 0.8 cm · 1374/1

Museum purchase

Wayang kulit are flat puppet figures
made of water buffalo skin. Gilded and
intricately painted, they are also finely
perforated, so as to cast large shadows
on a screen during night-long storytell-
ing performances throughout Indonesia.
The *dalang,* or puppeteer, narrates the
Wayang Purwa stories, which include the
Hindu epic *Mahabharata* in a contempo-
rary context. A hero of this epic, Arjuna,
is elegantly represented, his black face
rendered in profile and his long jointed
arms attached to controlling rods. The
colour black is used to symbolize the
character's maturity and serenity. The
size, colour and carving patterns of
wayang kulit were standardized under
the Islamic rule of King Radan Patah in
the sixteenth century, when new laws
prohibited the depiction of human forms.
Shadow puppets were produced in a
variety of styles. The fine puppet shown
here was purchased from the maker's
shop in Surakarta. (JKa)

Rangda mask

Bali, Western Indonesia
Twentieth century
Wood, paper, fibre, dye, hair, shell, paint
75 × 44 × 39 cm · 1249/1
Donation of Dr. Joyce Connolly

Rangda is an important figure in traditional Balinese mythology. Ritual dramas portray the terrifying demon queen engaged in theatrical battles with the benign Barong, who is attempting to restore order and balance to the world. Rangda is depicted here as a nude old woman with claws, pendulous breasts and a horrifying ivory-fanged wooden mask featuring protruding eyes, long unkempt hair and a tongue that extends to sixty centimetres.

It has been postulated that the character of Rangda derives from Mahendradatta, the Javanese queen exiled by King Dharmodayana in the eleventh century for allegedly engaging in witchcraft directed at the king's second wife. The exiled queen exacted her revenge by inflicting a plague on the kingdom before falling under the placating influence of a holy being. (JKA)

Bulul (rice granary or guardian figure)
Ifugao, Kiangan, Luzon, Philippines
Early twentieth century · Wood
59 × 20 × 19 cm · Ia332
Miguel and Julia Tecson Collection

The *Bulul* protect the production of rice, the most important component of the Ifugao diet. The figures are carved by specialists who are usually from the kin group of the patron. Ceremonies accompany each stage of production. The first seeks the approval of deities in the choice of wood, which is taken from the narra tree. The "entrance" ceremony takes place when the roughed-out carving is carried into the owner's house, where it is finished. Carving is done during the day, with the nights devoted to dancing and eating. Once the *Bulul* is completed, the myth relating to its origin is recited, and past powers bestowed are transferred to the present. The *Bulul* is bathed in pig's blood, then put in the granary. After a month or so, rice cakes are placed at the *Bulul*'s feet. At harvest time, he and other deities are invoked by priests and urged to join the festivities. The figures are believed to make rice grains multiply and to guard the harvest from vermin and thieves. (CM)

Martaban jar
Mindoro Province, Philippines
Ming Dynasty (1368–1644) · Clay, glaze
39.2 cm (diameter) × 43.5 cm · 1a262
Miguel and Julia Tecson Collection

In the Philippines, large storage jars such as this one were indispensable for domestic life, commercial transactions and long-distance trade. They were first made in China during the tenth century and distributed throughout Asia through the Burmese port of Martaban—hence their name. By the mid-thirteenth century, trade had increased significantly, and similar jars made in Vietnam and Thailand started to compete with the Chinese ceramics. Consequently, Martaban jars can be found throughout Malaysia, Indonesia, the Philippines and beyond. This spouted jar would have been used to ship liquids, perhaps wine, oil or soy sauce. Today, these storage jars are considered family heirlooms. They are also sought after in the West, where their curvilinear forms and their apparently casually glazed surfaces have made them objects of connoisseurship. (CM)

Cantonese opera costume and trunk

In the late nineteenth and early twentieth centuries, solidly built trunks containing materials for Cantonese opera performances were carried by ship from Guangzhou (Canton) to Honolulu and to North American cities with significant Chinese populations. The red trunks, the colour of good fortune, travelled with the itinerant actors, and they were carefully observed by prospective audiences upon their arrival, because the number of trunks indicated the wealth and status of the troupes. The trunks contained all that was needed to create the magic of Cantonese opera: costumes, headdresses, props, stage fittings, musical instruments and the shrine at which the actors worshipped their patron god before going on stage.

Why so many of the materials held in Vancouver were never returned to China remains something of a mystery. There is speculation that some actors married local people here and stayed in Canada, that some troupes ran into financial difficulties and had to sell their properties, and that some costumes went out of fashion. Thanks to the Jin Wah Sing Musical Association, the Museum of Anthropology has the largest known collection anywhere of early twentieth-century Cantonese opera materials. (ELJ)

Below: Master Toa Wong transforms a Cantonese opera actor into the God of Wealth for Vancouver's Chinese New Year parade, 2005. Photo: Ben Johnson

Guangzhou, Guangdong Province, China
Museum purchase

Trunk
c. 1920 · Wood, leather, iron, paint
102 × 86.5 × 78.7 cm · N1.867

Armour
c. 1920 · Silk, cotton, hemp, tin,
gold, silver, glass, rabbit fur, dye
165 × 136 cm · N1.681 a-c

Headdress
c. 1950 · Metal, glass, fibre, synthetic,
adhesive, paper, cotton
37.5 × 35 × 27 cm · N1.814 a-c

Boots
c. 1930 · Silk, cotton, leather, paint, gold, dye
43 × 24.5 × 7 cm · N1.751 a-b

Manchu style shoes
c. 1935 · Wood, paint, silk, cotton,
gelatine, leather
23.5 × 9.5 × 8 cm · N1.743 a-b

Snow cape

Guangzhou, Guangdong Province, China
c. 1920 · Silk, cotton, hemp, glass,
tin, silver, gold, dye, paste
124 × 82 cm · Edz1770
Donor: Jin Wah Sing Musical Association

This cape typifies the eye-catching splendour of very old Cantonese opera costumes. In the early twentieth century the costumes were decorated with mirrors, silver-plated discs and gold and silver thread so that they would sparkle on stage even if there was no electric lighting. This cape is very heavy because of the ornamentation and the weight of the fabric; silk woven with cotton combines sheen with strength. Costumes were often lined with hemp, which added to their weight. When the actors performed in the heat of a south China summer, they wore thick cotton padding underneath their costumes to absorb perspiration. Special shirts woven of fine bamboo tubes also held the costumes away from their bodies. Actors representing both men and women wore "snow capes" with matching hoods when the opera showed them travelling in harsh weather. The high collar on this one helps in establishing its age. (ELJ)

Rank badges

Chinese

Qing Dynasty Xianfeng and Tongzhi Reigns

(1644–1911) · Silk, gold, silver, dye

30 × 29.5 cm · *Top:* Edz1547 a-b;

Bottom: Edz1476 a-b

Donors: William E. Willmott and Donald Willmott

When Katharine Willmott and her husband, Earl, were Canadian missionary-teachers in Chengdu, Sichuan, itinerant antique vendors often spread wares on their veranda to tempt her. Her treasured collection was donated to the museum by their children.

During the Qing Dynasty, government officials wore rank badges on their plain, dark silk court surcoats (*pufu*) to indicate their place in the imperial hierarchy. Various animals differentiated military officials, while birds indicated the ranks of civil officials. Creatures were shown looking at the sun, which represented the emperor. During the Qing Dynasty, officials' robes opened at the centre front, so the front badges were divided in half. The image on the civil badge shown here was created by laid work or couching done with gold and silver thread, with the bird being appliquéd separately. The badge on the top belonged to a second-rank civil official, and the badge below, to a fifth-rank military official. (ELJ)

Dragon robe

China

Qing Dynasty, Xianfeng and Tongzhi Reigns
(c. 1850–1875) · Silk, gold, silver, dye

214 × 142 cm · 1050/1

Donors: Bernard and Ellen Lewall

An official wearing this dragon robe would have made a powerful impression on those who saw him. The nine elaborate dragons stitched onto the surface of the robe were imperial symbols, and the lavish silk, almost covered with heavy gold and silver thread, was in itself an image of wealth and power. The thread work is done with great skill, creating the textures of the scaly dragons, the rocks and the waves below.

The Qing Dynasty emperors were Manchu, and the cut and contours of their clothing reflected their identity as nomadic horsemen. The overlap at the front would have protected the wearer from the wind as he rode. The cuffs of the sleeves, called "horse-hoof cuffs" because of their shape, decorously covered the wearers' hands when he prostrated himself before the emperor. The bands on the sleeves look like the creases that would form as a horseman pushed up his sleeves. (ELJ)

'Farewell in the Garden'

Chinese
Qing Dynasty (1644–1911)
Paper, silk, pigment, ink
75.8 × 51.2 cm · N1.242
Museum purchase
(Leon and Thea Koerner Foundation funds)

In Chinese art, copying the work of earlier artists is considered a tribute to those artists rather than plagiarism or fraud. This painting, purchased by the Museum of Anthropology in 1961 on the advice of Dr. Ping-ti Ho, is now known to be titled *Farewell in the Garden*, thanks to the work of UBC graduate student Zoe Pei-Yu Li. Through her research, she determined that this is one of four extant copies, with similar poetic inscriptions, of a famous painting by the Ming Dynasty artist Wen Zhengming (1470–1559). Wen's painting was presented to his student Wang Chong (1494–1533) before Wang left to write the civil service examinations. Although both men failed the examinations numerous times, this scene of parting represents their commitment and struggle to serve the government through becoming officials, a deep-seated Chinese ideal. (ELJ)

177

Seal

Chinese

Qing Dynasty, Qianlong Reign (1735–1796) · Ivory

16 × 7.2 × 7.2 cm · N1.266

Museum purchase

(Leon and Thea Koerner Foundation funds)

In Chinese culture, the imprints of seals until recently served as signatures. The imprints indicate the authorship of paintings and calligraphy, and often serve as records of ownership for these works. The seals of scholars and artists are themselves works of art, with images intricately carved by specialists and with characters that are distinctively rendered. Seals also served as symbols of authority for imperial officials, giving force to edicts and proclamations.

Normally seals are made of stone, but this one was expertly carved from a large block of ivory. It carries great significance, since it was the official seal of the emperor, Qianlong, who reigned during most of the eighteenth century. The dragons that are entwined through the clouds in the seal's upper half are symbols of the emperor. (ELJ)

Figure of a dog

Chinese
Eastern Han Dynasty (25–220 CE) · Clay, glaze
33.6 × 32.7 × 12.5 cm · Edz4361
The Victor Shaw Collection of Chinese Arts

This lively dog was probably created to accompany his master or mistress in the afterlife. The Chinese ceramics from this early period that have survived are usually mortuary or burial objects, protected from damage because they were underground. There is a long tradition in China, continuing to this day, of providing images of the objects, animals and people, such as servants and guards, a deceased person will need in the next life. In the past these were made of ceramic, metal or wood and placed in the person's tomb. Now they are made of paper and include such modern conveniences as cellphones. This image appears to have been formed in a mould, with details shaped by hand and incised. The shiny green glaze is lead-based. (ELJ)

Plate

Jingdezhen, China

c. 1700 · Porcelain, paint

34.1 × 5.7 cm · Edz3130

Museum purchase (Fyfe-Smith Memorial
Oriental Collection Fund)

Blue-and-white porcelain was exported
from China to Europe in great numbers
during the Ming Dynasty (1368–1644),
but the wares made during the reign of
the Kangxi emperor (1661–1722), were
technically superior. This plate would
have been made at the imperial kilns
at Jingdezhen and exported, probably
to France, around the turn of the eigh-
teenth century. Images on porcelain of
Chinese scenery and people served as
one impetus for the flowering of the
chinoiserie art movement in Europe.
However, there was a fairly brisk trade in
the commissioning of European designs.
This plate is clearly a commissioned
work and was probably one of a set.
Although the image of two gentlemen
and a lady playing musical instruments
is derived from a 1690 engraving by the
French artist Robert Bonnart (1652–
c. 1729), the facial features are Chinese
and the figures are more wooden than in
the French original. (CM)

Buddha Shakyamuni

China?

Eighteenth century

Wood, plaster, fibre, lacquer, gold

1.5 × 1.1 × 0.8 m · N1.888

Donors: Trustees of H.P.B.

[Helena Petrovna Blavatsky] Library

Monumental yet serene, this striking gilt and lacquered wooden icon represents the historical Buddha, Shakyamuni, seated in the full lotus posture, *padmasana,* and displaying the earth-touching hand gesture, *bumisparsha mudra,* which signifies the attainment of Buddhahood through enlightenment. Signs of enlightenment, or *lakshana,* are clearly visible on this figure. The cranial bump, or *ushsnisha,* indicates the Buddha's special wisdom, and the tightly coiled ringlets of hair symbolize the Buddha's renunciation of worldliness. (JKa)

Budaixi glove puppet

Taiwan
Twentieth century · Paper, skin, metal,
silk, hair, lacquer, wood, cotton
44 × 28 × 8.9 cm · Ia57 a-b
Museum purchase

Budaixi is an active form of popular entertainment in Taiwan, utilizing costumed hand or glove puppets with painted wooden heads, hands and feet. A theatrical tradition originally imported from Fujian province in China, *budaixi* by 1900 illustrated distinctive Taiwanese traits, though the costumes of the figures continued to be patterned on Ming Dynasty dress (1368–1644). This character, Xu Wen, or bearded man, is represented by strong features and a long beard. His varnished white face, tinged with pink, symbolizes a malevolent personality, or *malkin,* as do his bared teeth and fixed stare.

The narrated stories played out in Taiwanese puppet theatre performances are adapted from novels, folk tales, history and stories of supernatural events. A troupe of seven men manipulate the puppets and narrate their roles while musicians relay the sound effects. (JKa)

Khakhazouk (ceremonial robe)

Tibet

c. 1850? · Silk, silver, gold, dye, fur

207.5 × 155 cm · 1022/1

Museum purchase (Fyfe-Smith Memorial
Oriental Collection Fund)

Of all the Tibetan robes in the museum's collection, this one is probably the most precious. Few of these robes existed in Tibet. This robe's value comes not only from its rarity but also from the splendid gold-and-silver eighteenth-century Russian brocade from which it was painstakingly pieced. Its multicoloured trim was created with very fine hand stitching, and the robe is edged with animal fur. The robe would have been worn with a fur collar lined with red brocade. *Khakhazouk* were created to be worn by government officials on special occasions.

The robe shown here was the hereditary property of Yapshi Yuthok, whose family descended from the family of the tenth Dalai Lama. The late Kungoe Yuthok was a cabinet minister in the Dalai Lama's government. It was the wish of his wife, Tsering Dolkar Yuthok, that the museum display the family's heirloom robe so that visitors could learn about Tibetan culture. (ELJ)

Prayer wheel

Tibet

Nineteenth century · Silver, wood

9 cm (diameter) × 29 cm · Ee4.42

Mr. and Mrs. F.A. Poole Sr. Collection

Vajra (thunderbolt)

Tibet

Nineteenth century · Bronze

4 cm (diameter) × 11 cm · 1707/2

Mr. and Mrs. Phuntsok Kakho Collection

Ghanta (prayer bell)

Tibet

Nineteenth century · Bronze

9.5 cm (diameter) × 16.5 cm · 1707/1

Mr. and Mrs. Phuntsok Kakho Collection

Butter lamp

Tibet

Nineteenth century · Silver

6.5 cm (diameter) × 9 cm · Ee4.30

Donor: Victor Hardy

Om Mani Padme Hum. The Jewel in the Lotus is the six-syllable mantra chanted by Tibetans to end the rebirth cycle in order to enter nirvana, the state of enlightenment. The predominant religion of Tibet is the Tantric, or Vajrayana, form of Buddhism. Tibetan art has a religious function, with a profusion of specialized ritual objects to aid the worshipper, produced by skilled craftsmen. The *vajra,* or thunderbolt, symbolizing compassion, and the *ghanta,* or prayer bell, symbolizing wisdom, are made of bronze. A lama, or priest, would hold one of these in each hand, uniting the symbolic qualities they represent by crossing his arms over his chest to represent the enlightened mind. The butter lamp, made from silver, would have been lit during the ritual process. The silver prayer wheel is decorated in repoussé, with mantras written on it in the *lant'sha* script. (JKa)

Uchikake (formal over-robe)

Japan
Before 1900 · Silk, cotton, gold, dye
160 × 122 cm · N2.214
The Bernulf and Edith Clegg Oriental Collection

Every arch-shaped panel on this kimono is embroidered with a different natural image, using many kinds of stitches and gold-thread couching. The makers probably created the mottled gold background by applying gold leaf or gold dust over an adhesive surface.

Although this garment was identified for many years as a kabuki theatre kimono, the fineness of the embroidery and the kimono's almost pristine condition called this into question. The puzzle was finally solved by Japanese classical dancer Eiji Toda and UBC Professor Colleen Lanki. The kimono bears many auspicious symbols, including cranes, turtles, Mandarin ducks, small oranges, peonies and narcissus, along with unopened *hamaguri* clams, which often represent young unmarried women. Flowers and plants represent the seasons. The garment has long sleeves, worn only by young unmarried women, and a padded hem, used in both theatre costumes and formal wear. The clues indicate that the wearer was a bride, probably a wealthy lord's daughter, and that this was her formal over-robe, or *uchikake*. (ELJ)

Tsuba (sword guards)

top:

Artist: Toshimitsu

Japan

1800–1825 · Bronze, gold

6.6 × 6 cm · Ed5.3139

Donor: Charles H. Stephan

 Marion Stephan Collection

Tsuba (sword guards) are much sought after by collectors of Japanese art because of their beauty, their metalwork and their significance. The *tsuba* protected the hand of the person using the sword, while giving the sword balance. Its owner's identity, beliefs and taste were reflected in the symbols it bore. The earlier of the *tsuba* shown (bottom) may predate the custom of artists signing their work. Its delicate decoration of chrysanthemums, cherry blossoms and butterflies overlaid with gold on a background of *nanako* work (tiny raised dots) suggests that it was meant for court use rather than fighting. The metal, bronze with a small percentage of gold, was pickled to achieve the blue-black colour. Toshimitsu, who made and signed the other *tsuba* pictured (top), created a composition of rice bales, a tree and two swallows on one side, with a tree trunk and roots on the other. The smaller hole served to hold the owner's utility knife. (ELJ)

Hikeshi Naga-Hanten

(fireman's protective coat)

Japan

Tokugawa Period (1603–1868) · Cotton, dye, paint

121 × 107.5 cm · 819/1

Museum purchase

In premodern Japan, wood was the primary building material, and so people had every reason to fear fire, especially in cities. According to classical Japanese dancer Eiji Toda, this coat probably was specially commissioned by a firefighter in the hope that it would offer him both physical and supernatural protection. It would have protected the fireman from blows, because it was made from many layers of cloth quilted together with closely spaced rows of strong, even stitching called *sashiko*. These layers of cloth could also absorb and retain water.

Eiji Toda and Professor Colleen Lanki agree that the striking image on the back of the coat is likely a Dragon God, or Water Spirit, called *Ryujin*. During firefighting, the coat would have been worn with the image inside, both to avoid damage to the design and for reasons of modesty. Once the fire had been extinguished, the coat may have been reversed, rather like a combatant might do after a fierce struggle. (ELJ)

Figure of a woodcutter

Japan

Nineteenth century? · Wood, ivory, lacquer

39.8 × 16.5 × 14.4 cm · Ed5.1439 a-b

Fyfe-Smith Collection

Whenever the museum puts this figure on display, visitors find it eye-catching. Why might this be? Is it the young woman's coy expression and charming pose, the fineness of the figure's craftsmanship, or the beautiful materials from which it was made? Likely the figure was made for foreigners to display as an example of Japanese art, but the artist who created it took great care in its execution.

The fact that the woman is young and unmarried is indicated by the length of her sleeves; they would hang down below her waist if she had not tucked them into her sash. The pack frame on her back and the hatchet in her hand suggest that she is going to cut firewood. Her relatively short kimono, straw sandals, head cloth and leg wrappings all indicate that she is a woman used to physical labour, but this does not detract from her beauty. (ELJ)

Magojiro (young woman) **Noh mask**
Artist: Erika Harada
Japan
c. 1980 · Japanese cypress wood, sizing, paint
26.5 × 20.5 × 11.5 cm · Ed5.2499 a
Donor: Minobusan Kuonji Temple
(in honour of Professor Shotaro Iida)

Hannya (jealous woman) **Noh mask**
Japan
Before 1820
Japanese cypress wood, sizing, paint
23.5 × 17 × 12.5 cm · Ed5.2497
Museum purchase (Fyfe-Smith Memorial
Oriental Collection Fund)

Men play both the male and the female roles in Japanese Noh theatre, and masks are worn primarily by the *shite* (main actor). Masks of women broadly represent female characterizations in *Katsuramono* (woman or wig plays). The jealous demon mask, *Hannya*, represents the fury of a woman transformed by jealousy and frustration. It is used in *Kijomono* (fiendish woman plays).

The mask is the most significant expressive vehicle in Noh plays. An actor is meticulous about choosing the right mask to enhance his interpretation of the role. From the moment the mask is secured on his face, the actor is regarded as completely transformed into the character he portrays. A mask can be fully appreciated only when it is brought to life by a great actor on stage. Hence, the more a mask is used in performances, the more artistic and historical value it acquires. (ELJ)

'Orchid Pavilion Gathering'

Artist: Fukuhara Gogaku (1730–1799)

Japan

Before 1799 · Silk, paper, paint, wood, fibre

79 × 36 × 1.5 cm · Edz1408

Charles and Aileen Walker Collection

This handscroll painting, collected by Canadian missionary doctor Richard Brown in Japan immediately after World War II, was for many years thought by the museum to be Chinese. The painstaking research of UBC graduate student Kazuko Kameda-Madar revealed it to be a Japanese painting by Fukuhara Gogaku, a known artist. The painting depicts an actual gathering of prominent scholars in China in the year 353; they were invited by the great writer and calligrapher Wang Xizhi to a poetry competition. In Japan, the event has been re-enacted since the tenth century, and artists have depicted it in paintings and prints. Gogaku's teacher, Ike no Taiga, produced numerous versions of the image to meet heavy demand from clients. In creating his own version of the painting, Gogaku was influenced by the Chinese literati style. He also introduced other innovations, including his own distinctive style. (ELJ)

Doll family

Korea

Late Choson Dynasty (before 1910) ·
Wood, silk, cotton, ramie, horsehair?
paint, paper, dye, paste, glass
left to right: 24.3 × 15.5 × 2.8 cm; 27.3 × 16 × 5 cm;
16.8 × 14 × 5 cm; 25.7 × 21 × 6.4 cm; 24 × 16 × 3 cm
left to right: N3.64, N3.62, N3.61, N360a-b, N3.63
Marion Stephan Collection

This family of dolls, meticulously identified by Dr. Choi, Hae-yool, a Korean costume historian, was probably custom made for presentation to foreigners, since within Korea dolls of this kind are very rare. The standard of workmanship is extraordinary. The dolls' bodies are made of wood, with articulated limbs, and each doll wears every item of clothing appropriate for his or her age and status. Their clothing and ornaments indicate that this is a family of the *yangban* class, the highest social class during the late Choson Dynasty. The family members include the father, with his *yangban* horsehair hat and formal garments, and the mother, with a green coat that she can put over her head for modesty when she goes out. The mother wears two pairs of under-trousers, the outer pair giving volume to her skirt. The couple have three children: a teenage girl and boy and a younger boy. (ELJ)

Court bag

Korea
Before 1910 · Silk, gold, dye
17.5 × 14 × 2 cm · N3.36
Marion Stephan Collection

Bags of this type are rarely available
for scholars to study, as they are passed
down through families as treasures.
According to costume historian Dr. Choi,
Hae-yool, this bag likely was made by an
embroiderer within the court, as indi-
cated by the tiny stitches at the top and
the burgundy colour, a royal prerogative.
The rock and wave designs are like those
on officials' robes, and the embroiderer
has added various auspicious symbols.

Both men and women wore such bags
at their waists to hold small articles,
although the bags were more decorative
than functional. The colours and deco-
rations on this bag indicate that it was
used by a woman. An embroiderer could
have made only a few bags of this com-
plexity in her lifetime. (ELJ)

Wine pot

Korea

Clay, glaze

Vessel: 20.5 × 17.5 × 13.5 cm

Lid: 6.5 cm (diameter) × 5 cm

N3.96 a-b

Marion Stephan Collection

This wine pot combines simplicity with elegance of line and form and is superbly executed. It is shaped like a melon, with a stemmed lid. Its grey-green glaze, generally known as celadon, has been popular in many variations throughout the Far East for a thousand or more years. The pot's semitranslucent, unctuous surface invites the touch of a hand, while the interior awaits filling. Perhaps this wine pot once served its purpose in a gathering of poets and scholars, at leisure at a picnic on the banks of a river, while the participants appreciated the first plum blossoms of spring. (ELJ)

Masks

Artist: Han, Changhyun (Kevin Han) (b. 1962)
Korean, made in North Vancouver, BC
2002–2003 · Gourd, paint, fibre,
cotton, paper, adhesive, dye
left to right: 54 × 28 × 7 cm; 20 × 19 × 4 cm
2669/1; 2669/3
Changhyun Han Collection

Performances of Korean masked dance drama have twice accompanied donations of Korean masks. The first, above, was in 1984. The second was on May 15, 2006. In a ceremony held in the Great Hall of the Museum of Anthropology, Mr. Han, Changhyun, donated ten masks that he had made. Following the donation ceremony, Mr. Han and the Traditional Korean Arts Society put on a special masked dance performance.

Mr. Han is a hereditary mask-maker in the tradition of the Sandae mask-dance drama of Songp'a. The characters shown here are *Somu,* the Flirtatious Young Woman, and *Senneem,* a Nobleman.

Mr. Han's generous donation greatly enhanced the museum's collection of Korean masks. In 1984, the government of Korea had donated thirty-three masks and related musical instruments to the

museum. Two forms of dance-drama were represented in this gift: masks of papier mâché, used in the Pongsan mask drama and made by Kim, Hi-soo, and masks of gourd from the Pyol Sandae Nori drama of Yangjyu made by Yu, Kyung-sung. (ELI)

facing page:
Korean Pongsan Dance performed in Great Hall at MOA, July 15, 1984. Source: MOA Archives

Bride's robe

Korea

1894–c. 1930 · Silk, dye, paper, paste, rayon?

197 × 120 × 3.3 cm · 2503/3 a

Museum purchase (Fyfe-Smith Memorial
Oriental Collection Fund)

facing page:

Groom's robe

Korea

c. 1890 · Silk, dye, paper, paste, rayon

179 × 131 × 3.7 cm · 2503/1 a

Museum purchase (Fyfe-Smith Memorial
Oriental Collection Fund)

These elegant robes are in the style of those worn in the Korean court. The groom's robe, shown on the facing page, is that of an official, and the bride's, shown above, that of a princess. The groom's robe, called *dan-ryeong,* is made of hand-woven silk gauze, indicating that it was worn in summer. With it he would have worn a rigid hoop belt embellished with plaques of gold, silver or ox horn; high boots; and a black hat with wing-like projections at the sides, with a short jacket and trousers bound in at the bottom underneath.

The bride's robe, called *gaesung won-sam,* was worn with the two front panels meeting at the centre. With it, depending on the district where she lived, she may have worn a black headdress or one with artificial flowers and ornaments of gold, silver and amber, as well as black hair ribbons stamped or embroidered with gold characters having auspicious meanings. Under the robe she would have worn a green or yellow jacket and a long red skirt. Her shoes were embroidered with flowers. (ELJ)

Notes

1. Personal communication between
 Audrey Hawthorn and Wayne Suttles,
 UBC professor, 1954.

8 The Oceanic Collection

Students who attended the University of British Columbia between 1927 and 1947 might have encountered the room on the first floor of the main library that housed a collection of ethnographic objects from Oceania, amassed and installed by Canadian writer and traveller Frank Burnett. Rows of exhibition cases crowded so closely together there was barely room to squeeze by. Weapons of all shapes and sizes were on display, along with boxes, baskets and bowls, helmets and hats, masks and mats, jewellery and all manner of other things. Anything that did not fit into the display cases was either placed on top or, in the case of the model canoes, suspended from the ceiling. Here and there small labels informed students that most of the objects were from the Pacific and had been collected sometime between 1895 and 1923. There was nothing to indicate that the collection was— and still is—the most representative Pacific Islands collection in Canada. As noted elsewhere in this book, in 1947 the collection was moved to the basement of UBC's Fine Arts library, where it remained in storage until the new Museum of Anthropology opened in 1976.

When Frank Burnett's collection first arrived at UBC, its value and potential for research were recognized by the university's chancellor. However, there were no anthropologists on faculty at the time. In 1942 a president's committee was struck to investigate the need for a museum to house the collection and for courses that would allow students to explore it. After the appointment of anthropologist

facing page:
Frank Burnett in his curio room, c. 1920. Photo: Francis Dickie. Reproduced by permission of the Vancouver Archives

Dr. Harry Hawthorn in 1947, the stage was set. In subsequent years the department of anthropology attracted Oceanic scholars such as Cyril S. Belshaw, Kenelm Burridge, Pierre and Elli Maranda, William McKellin and John Barker. The research and teaching interests of these faculty members had developed from their intensive fieldwork in the Pacific. In 1949 Audrey Hawthorn initiated the teaching of museum courses, and students utilized the collections, including Burnett's, in their course work, which included some attention to the practical aspects of cataloguing, conservation and display.

In 1976 the collections were moved to the new museum building, where they were installed in a then innovative system called Visible Storage. Although the Pacific Islands collection did continue to grow, benefiting from donations, bequests and some purchases, the museum did not actively collect objects from the Pacific until Vancouver hosted Expo 86, a World's Fair. The museum assumed the responsibility of designing and installing the South Pacific pavilion for the fair, and two staff members, Moya Waters and Herb Watson, were sent on a collecting trip to the Pacific. They returned with well-crafted contemporary works, many of which came to the museum when Expo closed.

In 1997, as the museum celebrated its fiftieth anniversary, the decision was made to research and exhibit Frank Burnett's founding collection of objects from the Pacific Islands. At first, research concentrated on Burnett's four books, his scrapbooks and his hundreds of photographs and collection catalogues. Burnett had collected during a time period—from the 1890s to about 1920—that has been labelled the "expedition period." Like the other collectors of the time, mainly academics doing fieldwork and collecting for institutions, Burnett travelled over large areas, visiting many different places for short amounts of time, though he stayed in the Solomon Islands for about six months. He was not a trained academic, yet he kept meticulous records of his collecting.

The documentation done in 1997 provided insights into the man and the spirit of his time, but current museum practice emphasized the importance of research based on negotiations and collaborations with originating communities. So the exhibition planned to showcase Frank Burnett's collection, opening the doors to an ongoing commitment to work collaboratively with Pacific Islanders, whether in their home communities or in British Columbia. The Pacific Islands Museum Association (PIMA) agreed to become a partner in the development of

the exhibition. "Pasifika: Island Journeys" was installed at the museum in 2004, opened by Lawrence Foana'ota, president of PIMA, and choreographed by the local Pacific Islands community.

During 2004, two other significant Pacific Islands collections came to the museum. First, eleven objects still in the possession of Frank Burnett's family were donated by Burnett's great grandson, Eric Groves, in memory of Josephine Groves, Burnett's granddaughter. Second, researchers Susan and Abraham Ross, who had worked in the village of Sirorata, in the Oro province of Papua New Guinea, in 1973, donated fifty-nine objects, a collection consisting mainly of everyday attire and domestic utensils. The significance of this collection lay in the excellent accompanying documentation, consisting of extensive field notes, tape recordings and photographs.

In recent years, the museum has established enduring relationships with local communities of Pacific Islanders and with museums and cultural centres in the Pacific. This has led to exchanges of personnel, workshops, exhibitions, internships and the signing of Memoranda of Understanding (MOU) with PIMA and the Fiji National Museum.

In 2006 the museum received a donation of five objects from the Pacific that had been owned by the Reverend John Williams (1796–1839), a well-known missionary killed on the shores of Erromango, Vanuatu, in 1839. This small collection is remarkable for a number of reasons. It is probably the oldest collection of Pacific material in Canada, and the individual objects—three clubs, a whisk and a musical instrument—are classic examples of early nineteenth-century work. More importantly, the collection began a conversation among the family, the museum and the chiefs of Erromango that culminated in a historic meeting on the 170th anniversary of Williams's death.

Also in 2006, the museum secured the Andrew Fellowship, a fund made available to visiting artists from overseas. In consultation with the Alcheringa Gallery in Victoria, which has long-standing contacts with artists in Papua New Guinea, the museum chose master carver Teddy Sapame Balangu as the recipient of the fellowship. Salish artist John Marston travelled to the Sepik to meet and work with Balangu, and later Balangu spent five months at the Museum of Anthropology, during which period he created an exquisite carving for the collection, *The Fisherwoman,* based on a clan story. Balangu's main task was to carve a three-metre clan pole to be installed as a signature work in the museum's Multiversity Galleries. This exchange became the topic of a film entitled *Killer Whale and Crocodile.*

In 2008 two model canoes were commissioned from Vanuatu and New Caledonia artists for display in the museum's Multiversity Galleries, along with a contemporary painting by Vanuatu artist Moses Jobo. In 2008 Carol E. Mayer made a field trip to Teddy Balangu's village to receive his new carving of a killer whale, inspired by a whale he had seen when travelling by ferry to Vancouver Island and which had become a recurring image in his dreams.

Object descriptions researched and written by Carol E. Mayer (CM).

Bark painting

Artist: Yilgari

Liagalawormiri clan, Milingimbi, northeastern
Arnhem Land, Northern Territory, Australia
Before 1957 · Bark, ochre pigment, clay, charcoal
79.8 × 35.3 × 3.5 cm · C1697
Transfer: University of Melbourne

This painting depicts events associated with Yulunggul, the mythic Rainbow Snake who travelled across the swamp country in Australia's Northern Territory. He is shown here resting on the rails of a hut, guarding an area that makes up a camp. The semicircular shapes are oysters in the salt water.

Designs found in the bark paintings of western Arnhem Land have a history believed to reach back some fifty thousand years. The paintings migrated from rock walls to bark shelters, where they were used to illustrate the ancestral and transformation stories told during the wet season. In northeastern Arnhem Land, sacred clan body painting designs were transferred to bark in response to the demand for portable art from missionaries and anthropologists. In the 1930s missionaries asked Milingimbi artists to produce bark paintings for sale in the cities. Today, these paintings, collected for their aesthetic qualities as well as their ethnographic significance, are recognized as a dynamic form of contemporary Australian art. (CM)

Tekoteko (gable figure)
Maori, Aoratea, New Zealand
c. 1860s–1880s · Totara wood
59 × 15 × 11.3 cm · C985
Transfer: Altman Antiques

The museum's collection of 124 Maori objects is small, but it does contain a few pieces of note. When Maori scholar Paul Tapsell visited the museum in October 2008, he paid particular attention to the *tekoteko* shown here, an ancestral guardian. *Tekoteko* are positioned at the top of the gable on Maori ancestral-chiefly houses. This one would have carried an important ancestral name, and people would have acknowledged his presence at meetings (*hui*) on the house's forecourt (*marae*). His features have been softened by many years of exposure to the elements. Even though he has been removed from his ancestral house, this *tekoteko* retains a powerful agency (*ihi*—presence, *wehi*—awe and *wana*—authority) that sets him apart from the rest of the collection. (CM)

Mere totoaka (short club)
Maori, Aoratea, New Zealand
Nephrite
31.4 × 10.5 × 1 cm · C1131
Transfer: Otago Museum

This *mere* was also identified by Maori scholar Paul Tapsell as an important *taonga* (ancestral treasure) in the museum's collection. It would have been held by a high-ranking male leader and viewed as a symbol of great *mana* (prestige). This *mere* is made of a rare form of *pounamu* (nephrite) called *totoaka,* which symbolically represented the streaked blood of fallen enemies. In addition, its white streaking (*inanga*) and translucency make this *mere* unique. Its smooth, waxy surface would have been achieved through years of abrasion with fine sand and water. Traditionally, the sharp edge of a *mere* was used to kill someone with a single thrusting blow, to the head (cleaving the upper skull horizontally), the neck (smashing the windpipe) or the body (penetrating the ribs and stopping the heart). This *mere* would have carried a significant ancestral name, honouring both the holder and those whose lives had been taken. (CM)

Tahiri ra'a (fly whisk)
Austral Islands
Before 1839 · Wood, fibre
37.5 × 3.3 cm · 2670/5 a-e
Collection of the missionary
Reverend John Williams

Tahiri ra'a such as this one probably served as a symbol of rank. The top consists of two figures seated back to back with their hands over their abdomens. They could be of some genealogical importance or are perhaps representations of deities or other supernatural beings. The angular rhythm of the design begins with the forward thrust of the heads, the squared shoulders and the sharply bent knees and is carried down the handle by a series of discs.

This particular *tahiri ra'a* was once owned by the Reverend John Williams, a missionary in the South Pacific from 1816 until he was killed on the shores of Erromango, Vanuatu, on November 20, 1839. One of Williams's Canadian descendants, Michael Williams, donated the *tahiri ra'a* to the museum in 2006. A reconciliation ceremony between the people of Erromango and the descendants of John Williams was held in Erromango on November 20, 2009, the 170th anniversary of Williams's death. (CM)

Barkcloth

Barkcloth, commonly known as *tapa,* is one of the most distinctive products of the diverse cultures of the Pacific Islands. The name is derived from the Samoan word *tapa,* which means the undecorated edge of a piece of barkcloth, and the Hawaiian word *kapa,* a variety of barkcloth. *Tapa* was probably brought to the Pacific thousands of years ago by the ancestors, who also brought with them a distinctive patterned pottery, Lapita. Both are viewed as sources of creative expression for women across the Pacific. No important occasion is complete without the presence of *tapa,* and those who make it continue to generate techniques and designs that serve both utilitarian and ceremonial purposes. Whether its designs are found printed on a cotton shirt, a plastic cup or a set of paper napkins, *tapa* marks the special identity of Pacific Islanders around the world. (CM)

below: Faamuli Salu, *siapo* maker, Salelologa, Savai'i, Samoa, 2000. Photo: Carol E. Mayer

facing page, clockwise from top left:

Tapa (barkcloth)
Maisin, Papua New Guinea
c. 1982 · Mulberry bark, paint
160 × 80 cm · 1019/3
Donor: John Barker

Zigotu (barkcloth)
Santa Isabel Province, Solomon Islands
c. 1909 · Mulberry bark, paint
303 × 87 cm · C933
The Burnett Collection

Nemasitse (barkcloth)
Vanuatu
Before 1960 · Mulberry, paint
205 × 87 cm · C1280
Donor: Union College

Ngatu (barkcloth)
Artist: Alice Fale
Nuku'alofa, Tonga
c. 1976 · Mulberry bark, paint
420 × 196 cm · 681/1
Donor: Perry Millar

Siapo (barkcloth)
Artist: Faamuli Salu
Savai'i, Western Samoa
c. 2000 · Mulberry bark, paint
182.5 × 97 cm · 2533/4
Museum purchase (field collected)

Masi (barkcloth)
Ratu Lake, Fiji
Before 1959 · Mulberry bark, paint
318 × 81 cm · C1253
The Belshaw Collection

Totokia (pandanus or
battle hammer club)
Kuba Village, Fiji
Before 1910 · Wood
80.5 × 27 × 11.4 cm · C1052
The Burnett Collection

Prior to the mid-nineteenth century,
warfare was ever-present in Fiji. All male
children were trained from infancy in
the wielding and parrying of clubs and
other weapons. Clubs were the Fijians'
favourite weapon, and a greater variety
of forms was found there than anywhere
else in the Pacific. Some forms had spe-
cific functions: this *totokia,* for example,
was intended to drive a hole through the
enemy's skull. Clubs owned by chiefs or
great warriors were buried with them as
protection on the perilous journey to the
afterworld. The contemporary respect
for the *totokia* is demonstrated by its
appearance in the arms of a warrior on
the Fijian National Coat of Arms. (CM)

Tanoa (bowl)

Fiji

After 1950 · Vesi wood, shell, coconut fibre

48.3 × 14.3 cm · 553/1

Donor: William S. Hoar

The *tanoa* is central to the *yagona* (kava) rituals. *Yagona,* derived from the pepper plant, is mixed with water and served with appropriate ceremony in coconut cups. The *boss,* or suspension lug, under the lip of the *tanoa* should face the highest chief present. Attached to the lug is the *watabu,* or sacred cord, made from coconut fibre and decorated with white cowrie shells—symbols of divine fertility. The *watabu* from each *tanoa* is extended towards the principal chief present, and it is said that death was the punishment for those who crossed this "line." Today, the *tanoa* and the drinking of *yagona* are recognized as fundamental to Fijian culture. The ritual is practised in all parts of the world, wherever Fijians have settled. (CM)

Faa (man's comb)
Kwaio, Malaita, Solomon Islands
Early twentieth century
Tree fern, orchid vine, morinda bark and root
22.3 × 9.3 × 2 cm · C1415
Donor: Dr. Niemi

The distinctive, finely plaited *faa* made
by the Kwaio women of Malaita Island
are traded throughout the Solomon
Islands. They are worn by men, often
together with similarly plaited ear
sticks. The teeth of the *faa* are made
from split sections of the core of tree
ferns. The yellow and red pigments
used to dye the orchid vine used for
plaiting are derived from the bark and
root of the Morinda plant, commonly
known as *noni*. Today, these combs
are still being made as a source of cash
income. (CM)

Mbarava (funerary plaque)
Kea Village, Bugutu, Solomon Islands
Before 1909 · *Tridacna gigas* (giant clam)
24.2 × 23.3 × 1.3 cm · C189
The Burnett Collection

This carved funerary plaque is made from the shell of a giant clam, a species once abundant in the seas around the Solomon Islands. Similar plaques have been kept in the burial shrines of important men. The collector, Frank Burnett, knew it was unusual to secure such a large and intact portion of a traditional plaque. In his notes, he wrote, "When it is taken into consideration that this work must have been done with strips of bamboo, in lieu of a saw, one can realize the vast amount of labour involved. I know of only two other pieces in existence." Today the giant clam is considered vulnerable, and protection programs are in place to ensure its survival, both as an important food source and as a source of material for the manufacture of jewellery and other items. (CM)

Fish carving

San Cristobal Makira-Ulawa Province,
Solomon Islands

c. 1909 · Milky pine wood, pava shell, paint, resin
90.5 × 38 × 29 cm · 2642/5
The Burnett Collection (Eric Groves)

This inlaid fish, probably a bonito, is modelled on larger versions that had cavities carved in them to hold ancestral skulls. The larger versions of the fish were kept in the canoe house, alongside the war canoes, and smaller versions such as this one were made for travellers. This particular fish has had a long and interesting journey. It was collected in 1909 by Frank Burnett, who kept it in his curio room until giving it to his granddaughter, Josephine Groves. She took it to Oregon, where it remained until her death in 2002. The fish then travelled farther south, to San Diego, with her son, Eric Groves, who donated it to the museum in 2004. (CM)

Kulap (funerary figures)
New Ireland, Papua New Guinea
Early twentieth century · Chalk, paint
left to right: 41.8 × 12.7 × 11.8 cm;
47.5 × 14.4 × 13.7 cm; 17.6 × 6.5 × 5.5 cm
C380; C381; C1302
The Burnett Collection

These chalk figures, called *kulap,* were
commissioned from specialist carvers
in the Rossell Mountains of New Ireland
to serve as representations of recently
deceased people. A *kulap* held the spirit
of the deceased so that he or she would
not wander aimlessly and perhaps
cause harm to the living. It was kept in
a shrine, where it remained until the
funerary rites conducted by men were
completed. Women were not allowed
access to the shrine; they had to stay
outside the enclosure to mourn their lost
relative. When the funerary rituals were
complete and the spirit of the deceased
had departed, the *kulap* was destroyed.
During the colonial period, *kulap* were
also sold to Westerners. (CM)

'Big Fish'

Artist: Teddy Sapame Balangu (b. 1961)
Iatmul, Palembei Village, Sepik River, Papua New Guinea
2008 · Wood, paint, shell
127 × 29 × 27 cm · 2725/1
Museum purchase (field collected)

Prior to the arrival at the museum in 2006 of Teddy Balangu, master carver from Palembei Village, Papua New Guinea, arrangements were made to ship a garamut log from Papua New Guinea to Vancouver, where it was going to be transformed into a clan pole. The log never arrived, but Balangu created two clan poles during his time at the museum—one of birch and one of spruce. They were the first to be created outside of his village, and he obtained both the stories they depicted and the permission to carve them from the clan leaders. Based on his experiences in British Columbia, Balangu also created this interpretation of a killer whale, titled *Big Fish*. It is both a work of art and a fascinating hybrid, part whale and part river fish. (CM)

Ladles

Boisa Island, Madang Province,
Papua New Guinea
front to back: c. 1972; c. 1964 · Kwila wood,
garamut wood, coconut shell
59 × 12.7 × 12.7 cm; 56 × 12 × 12 cm
Ie439 a-b; Ie440
Museum purchase

These two ladles were collected on Boisa
Island, situated off the north coast of
Papua New Guinea. Boisa is one of a
group of islands that receives fresh
water from the Sepik River as it flows
into the Bismarck Sea. The handles
of these ladles are covered with well-
carved, stylized designs of spirits or
ancestral figures, the emphasis being on
their beaklike noses. The bowls, made
of coconut shell, are tied to the handles
with cane. This kind of ladle is used
to serve soup prepared from fish parts,
coconut milk, water and various veg-
etables and leaf materials. Ladles such
as these illustrate the makers' ability
to combine fine artistry with efficient
function. (CM)

Ganda or gibi-gibi (face mask)
Sirorata, Oro Province, Papua New Guinea
c. 1973 · Boar tusk, paper, seed, shell, plant fibre
18.1 × 6.6 × 2.8 cm · 2623/4
Dr. Abraham and Ms. Susan Ross Collection

The *ganda,* or *gibi-gibi,* was worn by warriors during battle and on ceremonial occasions. In the photograph reproduced on the facing page, the *ganda* is worn by Mark Gorovari during a greeting ceremony organized for anthropologist Susan Ross when she arrived in Sirorata. A small bar across the back of the mask is clenched between his teeth, so that the mask frames his face. When not being worn, the mask hangs on the chest, functioning as a body ornament. (CM)

facing page:
Mark Gorovari at greeting ceremony.
Photo: Susan Ross

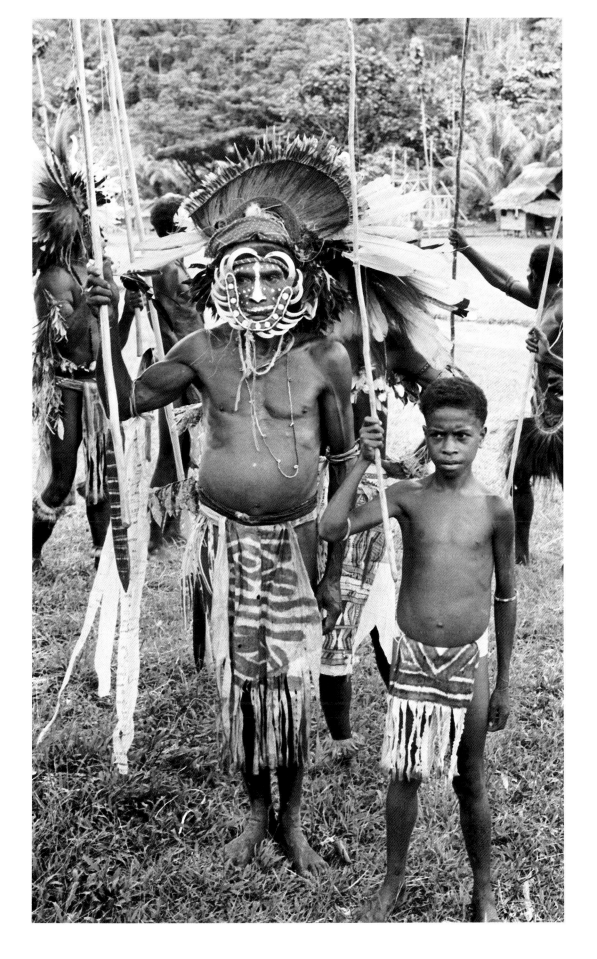

Temes Nevinbur (dance staff)

Malekula, Vanuatu
c. 1970 · Coconut, plant fibre, pigments, cobwebs,
pig tusks, wood
73.5 × 30 × 28.5 cm · 2596/6
Donor: Frits Bossen

Temes Nevinbur such as this one are used
as puppets during complex initiation
ceremonies on the island of Malekula,
Vanuatu. The ceremonies, enacted by
the Nevinbur secret society, are based
on a myth about resurrection particular
to Malekula Island, which involves the
symbolic destruction of a family. The
adults are personified by life-sized pup-
pets and the children are represented by
effigies on staffs—*temes*. Participation in
the ritual is confined to members of the
Nevinbur secret society and new initi-
ates. All others are kept behind a fence,
their view restricted to the tops of the
temes that are held up and danced dur-
ing the ceremonies. At the end of the
ceremonies, the life-sized puppets are
speared and burned, and some, or all, of
the *temes* are destroyed. The exaggerated
features on the modelled faces of the
temes are rather comical, though the cer-
emonies are viewed as both serious and
sacred. (CM)

Ua (eel trap)
Kiribati
Before 1902 · 87.5 × 54 × 36.3 cm
Wood, plant fibre · C828
The Burnett Collection

Eel fishing with traps is one of the oldest traditional methods of fishing still practised in the Pacific. When Frank Burnett collected this eel trap, he wrote, "The circular entrance seen in the front of the trap runs about three-quarters of the length of the trap and narrows gradually. Beyond its end, bait is placed. The fish swims in and passes out of the circular tube into the confines of the trap and strangely enough never realizes it can get out the way it came. Instead [it] remains in the area surrounding the tube until the fisherman draws up the trap and lifts the captive out through a little door as shown on the top." These house-shaped traps, unique to Kiribati, take about four days to build. Although the heavy shrub or ironwood is sometimes replaced with wire, the people of Kiribati want people beyond their shores to know they still use the traditional methods. (CM)

9 The Historic Photography Collection

Archives are often thought of as hidden places where treasures languish, waiting to be discovered by intrepid researchers who must fight their way through dirty basements and dusty boxes. Minus the dirt and the dust, the archives at the UBC Museum of Anthropology have long been such a place, remaining in the shadow of the Great Hall, the Visible Storage galleries and the museum's exciting exhibition schedule and public programs. Yet the archives have quietly cared for the museum's "secret" materials for more than forty years. The work the museum has undertaken is well represented, and the archives' holdings include textual records, audio recordings and moving image collections featuring scholars, educators and Northwest Coast artists. Also available are manuscripts, scrapbooks, diaries, correspondence and other donated materials that relate to the thematic interests of the museum. Among the archives' assets are approximately 90,000 photographs.

These photographs are impressive not just in number but in their range and diversity. In addition to recording the museum's development since the late 1940s, they depict peoples and cultures from around the world. Every continent, with the exception of Antarctica, is represented. From Africa, there are photographs taken by Leonard Humphreys while he was in the Sudan Civil Service from the 1920s through the 1940s, and images of Central African people taken circa 1905 by Alexander Frederick Wollaston, a geographer, botanist, naturalist and explorer. From Asia, there are images of Tibet, China, Hong Kong, Japan, Korea

and India, with the earliest examples being glass lantern slides taken in Formosa (Taiwan) and Japan between 1894 and 1902. Images of North American indigenous peoples form a significant part of the holdings, and there are photographs depicting many Northwest Coast cultures, as well as cultures from Central Canada, the Arctic and the U.S. Southwest. From South America, there is a series of photographs taken in the late 1980s of a family of cloth makers living in Taquile, Peru. Finally, the Oceanic region is well represented with images from Fiji, Papua New Guinea, Hawaii, Samoa, the Philippines, Solomon Islands and Indonesia. The dates on the photographs in the archives range over a hundred years and run the gamut from the historical to the contemporary, covering a multitude of subjects.

The photographers responsible for the images in the museum's archives come from many backgrounds: missionary work, the military, aid work, teaching and anthropology. Others travelled for personal interest and the promise of adventure. The reasons people were in foreign lands and the length of their stay influenced the type of photographs they took. Some images were observational, preserving memories of the curious and the unknown; others offer more in-depth and sensitive portrayals of people and places. Dr. Stuart Schofield, for example, took numerous photographs when he travelled to Hong Kong, Singapore, Shanghai, Beijing, Yokohama and Nagasaki in 1923 and 1924 with his wife, Florence. Dr. Schofield, a professor of structural geography at the University of British Columbia, was visiting these areas to produce geographic surveys, but he took a profound interest in the people and landscape around him. Florence Schofield compiled the photographs into an album in 1925, annotating them with captions. The images and comments together form a unique glimpse into the East as seen through the eyes of two Western travellers.

The approximately seven hundred photographs Lt. Col. Eric Parker took in Tibet in the early 1920s are another example of someone interpreting the East through a Western lens. Parker, a British military commander with the Indian government, led a little-known expedition to Tibet in 1921. In 1923, he conducted basic and advanced military training of Tibetan soldiers at the request of the Tibetan military. A year later, the Dalai Lama dismissed the British-trained officers due to pressure from monks, but Parker and his wife stayed on in Tibet for another year to operate a trading post. What makes Parker's photographs extra-ordinary is the range of subjects he recorded: military scenes, festivals, people from all levels

of society, architecture and landscapes. A small number of the images predate Lt. Col. Parker's time in Tibet and are believed to have been given to him by someone else. The most significant of these are photographs of the Dalai Lama, taken circa 1910 or 1911. All of these images capture a particular time and place, and they are especially important because the history of Tibet has long been the subject of study and debate. The potential of the photographs to enhance scholarship in this area is invaluable.

Many of the photographic holdings in the archives are connected to anthropological fieldwork or museum research. The 1970s are particularly well represented with images of Indian craftspeople in Bengal and Tamil Nadu taken between 1974 and 1977 by Stephen Inglis, who received his PhD in Anthropology from UBC in 1984. Another beautiful group of photographs are those taken by Dan Jorgensen in Papua New Guinea in 1974 and 1975 while he was there doing fieldwork for his PhD thesis. Initially interested in local politics, Jorgensen shifted his focus to the initiation cult and mythology of the Telefomin people. His images are outstanding for his sensitive depiction of the people he photographed as equals, in contrast to the depersonalized representations common in earlier examples of anthropological visual recording. Papua New Guinea achieved independence in 1975, and the lives of the people Jorgensen photographed changed greatly with the influx of renewed Christian evangelism, the development of large-scale mining projects and the advent of globalization. His images remind us of a time when their lives were closer to their indigenous traditions.

The archives at the Museum of Anthropology continue to expand, and new acquisitions enhance the potential for research and study. A recent donation of approximately 55,000 photographs taken by Vickie Jensen over three decades of working with First Nations communities on the Northwest Coast is particularly outstanding. Jensen's photographs document important events in the lives of the Kwakwaka'wakw, Eastern and Western Gitxsan, Quileute, Shuswap and Musqueam people, and also the work processes of major artists such as Norman Tait. Jensen and her husband, linguist Jay Powell, worked with Aboriginal elders and teachers involved in language and culture revitalization work, producing almost forty schoolbooks in various indigenous languages. Jensen's photographs, taken with the permission of community members, record a period of intense cultural renewal. Her donation was accompanied by Jay Powell's linguistic materials:

audio recordings and textual records. Together, they form a very important cultural, historical and ethnographic resource.

The photographic materials in the archives say as much about the photographers as they do about the subjects. Over time, preconceptions and prejudices have shifted to a more personalized, participatory way of interacting with and depicting world cultures. As a source for research and study, the museum's archival photographs reflect these trends. Regardless of what they depict, these photographs provide a means not only to understand others, but to understand ourselves.

facing page:
This image is from a scrapbook compiled by Leonard Humphreys to chronicle the time he spent in Sudan between 1924 and 1947. The man in the picture, who is from the Latuka tribe, worked as a postman. According to Humphreys, the man ran seventeen miles through leopard country to deliver a letter, and seventeen miles back to report that the task had been completed. The letter itself is lodged in the stick the man is holding. *Leonard Humphreys fonds, MOA Archives*

Until 2008, a group of sixty-five archival photographs from Africa and New Guinea remained a mystery to the museum. They came from the Vernon Museum and Archives, and the only information available was that they had been mailed to F.E.R. Wollaston at the Coldstream Ranch in Vernon, British Columbia, circa 1920. In researching images for this book, we discovered that the photographer was Alexander Frederick Richmond (A.F.R.) Wollaston, the brother of our man in Vernon. A.F.R. Wollaston was a traveller, explorer and adventurer of the kind found in the early years of the twentieth century. His many trips included voyages to Africa, Asia and Oceania. The images reproduced here show a woman from the Congo, circa 1905, and one of a group of indigenous Tapiro in New Guinea, known as Dutch New Guinea when the photograph was taken, circa 1909–1912. *F.E.R. Wollaston fonds, MOA Archives*

This image shows Professor Stuart
Schofield and his wife, Florence
Schofield, in a rickshaw in what
appears to be Japan, circa 1923 or 1924.
Describing her experience in Kobe,
Mrs. Schofield noted the crowds and the
manner in which the people dressed—
men in Western attire and women
in traditional kimonos. *#9A, Stuart
Schofield fonds, MOA Archives*

Stuart and Florence Schofield visited
a number of different countries and
cities on their voyage. This photo-
graph, included among 143 of the same
provenance, shows a harbour scene in
Singapore. *#12A, Stuart Schofield fonds,*
MOA Archives

Pictured here is Fumasinen, a prominent woman of Dalduvip, Papua New Guinea. According to the photographer, Dan Jorgensen, who was in Papua New Guinea between 1974 and 1975, Fumasinen was held in great respect in her hamlet and was highly regarded for her animal tending skills. Men from the community eagerly sought her out to tend their piglets. In the photograph, Fumasinen carries a young piglet as she begins her journey to a distant garden. *#F15, Dan Jorgensen fonds, MOA Archives*

left:

On September 16, 1975, Papua New Guinea achieved a peaceful independence from Australia. The event was cause for extensive celebration, and Dan Jorgensen was there to observe and record events. This photograph shows a Telefomin man dressed in traditional dancing attire. *#D21, Dan Jorgensen fonds, MOA Archives*

234

These two images, taken by Lt. Col. Eric Parker in 1923 or 1924, show the Gyantse Horse Racing Festival. This type of event was important to the Tibetan people from a religious and a social perspective as well as for general entertainment. Traditionally, the Gyantse festival, which continues today, takes place in June and features archery and equestrian events. The photograph on the facing page shows Jongpen, a Tibetan lay official, with his attendants. As befits the occasion, he is wearing his best clothes. In the image above, the Tibetan cavalry participate in the competitions. *Eric Parker fonds, MOA Archives*

236

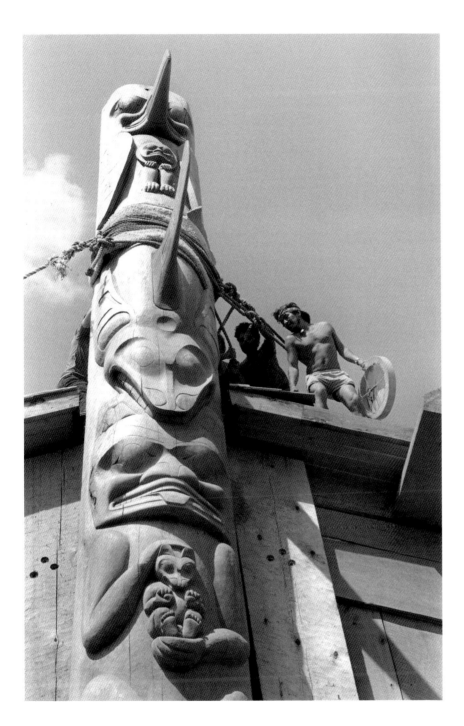

The women and the photographer in this image taken by Lt. Col. Eric Parker in Tibet in the early 1920s are not identified by name. The photo exemplifies the issues that can arise regarding both the relationship between a photographer and his or her subject and how an image is subsequently viewed. The image also raises questions about appropriation, ownership, cultural sensitivity and diversity. *Eric Parker fonds,* MOA *Archives*

In March 1985, photographer and author Vickie Jensen began documenting the three-month process of carving a totem pole for the Native Education Centre in Vancouver by artist Norman Tait and his apprentices. A series of images record the process from start to finish, from rounding the log, to roughing the pole, to the finishing stage where the finer details were completed. The final step was installation, shown here. Norman Tait is standing to the right of the pole, holding a drum. *Vickie Jensen fonds,* MOA *Archives*

About the Editors

KEN MAYER

Carol E. Mayer is head of the Curatorial Department at the Museum of Anthropology and associate to the University of British Columbia's Department of Anthropology. She holds degrees from the University of British Columbia, Cambridge University and the University of Leicester. She is internationally known for her work as a museum curator, has published widely on museum-related topics, has curated more than forty exhibitions and is the recipient of numerous international awards and fellowships. Mayer is responsible for the museum's Oceanic and African collections.

SKOCKER BROOME

Anthony Shelton is a leading scholar in museology, cultural criticism and the anthropology of art and aesthetics. In 2004, he was appointed director of the Museum of Anthropology and professor in the Department of Anthropology at the University of British Columbia. He has taught at the universities of East Anglia and Sussex; University College, London; and Universidade de Coimbra, Portugal, and has curated for the British Museum; the Royal Pavillion, Brighton, and London's Horniman Museum. Shelton's particular area of expertise is the indigenous and performative arts of Mexico and South America.